THE ABSTRACT IMPULSE:

Fifty Years of Abstraction at the National Academy, 1956–2006

The Abstract Impulse

Fifty Years of Abstraction at the National Academy, 1956–2006

MARSHALL N. PRICE

With a foreword by Jules Olitski

Introduction by Annette Blaugrund

and additional contributions by
Cindy Medley Buckner and Monica Steinberg

NATIONAL ACADEMY MUSEUM & SCHOOL OF FINE ARTS / NEW YORK
In association with Hudson Hills Press 2007

For Jules Olitski, NA

(1922–2007)

Published on the occasion of the exhibition "The Abstract Impulse: Fifty Years of Abstraction at the National Academy, 1956–2006" at the National Academy Museum and School of Fine Arts from August 1, 2007 to January 6, 2008.

Published with the support of the Dedalus Foundation, Inc.

Major support for this catalogue and exhibition was provided by The Alex J. Ettl Foundation, the Robert Lehman Foundation, the National Academy's Lucelia Fund for Publications, the Bonnie Cashin Fund, and the Cape Branch Foundation.

Additional support was provided by one anonymous donor, Mr. and Mrs. John Schobel IV, Messrs. John Schobel V and Daniel Dean Schmeder, the Anita Shapolsky Gallery, the Mersky Family Foundation, the Greenberg Van Doren Gallery, the Fifth Floor Foundation, Mr. and Mrs. Maurice Katz, the Katharina Rich Perlow Gallery, and Dorothea Rockburne.

Published by:
National Academy Museum
1083 Fifth Avenue
New York, NY 10128
www.nationalacademy.org

In association with Hudson Hills Press
3556 Main Street, Vermont 05254
Executive Director: Leslie van Breen

ISBN-10: 1-887149-17-1 (pbk.)
ISBN-13: 978-1-887149-17-4
Library of Congress Control Number: 2007930124

Photography: Glenn Castellano: front cover, back cover, frontispiece, pages 20–24, 29, 30, 32, 34–76; Grey Kitchen: page 33; Stephen Petegorsky: page 31
Frontispiece: Jules Olitski, *Salome Rock* (detail), 1990, acrylic on canvas, 48 × 24 inches. Art © Estate of Jules Olitski/Licensed by VAGA, New York, NY
Designed by Rita Lascaro
Printed by Evergreen+Central
Printed and bound in the United States

First edition

Contents

Foreword: Looking at Abstract Art

As a teenager I believed representational art was the only art that counted. I spotted reproductions of "modern painting" in art magazines, probably by Picasso and Braque, and scoffed. I didn't understand this art and I wasn't open to seeing it. Then something happened that changed the way I looked at art, all art.

My stepbrother's girlfriend knew José Clemente Orozco, the Mexican muralist, through her family's connections with him. He was at the time in New York, staying at The Pierre Hotel. Would I like to meet him? Would an eighteen-year-old boy from Brooklyn like to meet a world famous artist? What a question!

An appointment was made. Walking into the elegant Pierre Hotel at the time seemed to take even more courage than what I needed to present myself to and speak with a master. He was seated in the lobby, and I joined him there. I, being a know-nothing at the time, took it for granted that he would join me in condemning the art then being made in Paris by Picasso, Braque, and Matisse. Orozco, however, did not hesitate in setting me straight. He looked me in the eyes and asked, "Do you speak Greek?"

I wondered at the question and said, "No, I do not speak Greek."

He responded quietly, "Well, a lot of people do. You are ignorant of that language."

I suddenly realized I was in deep water and couldn't swim.

He continued speaking in a soft voice, "Art is a language and it must be learned. These artists you speak of, you just don't know the language they speak."

He was telling me to go and look again, but this time with my eyes opened. And boy, did I start looking.

After a lifetime of looking at art, great art, interesting art, uninteresting art, I have come to a simple conclusion. For the record, I make no distinction between abstract art and representational art. What is important is quality. A good painting, whether abstract or representational, lifts me up, gives me pleasure. A good painting is alive. And a good painting has its own beauty.

Jules Olitski
23 January 2007

Director's and Curator's Acknowledgments

We could not accomplish this important work without major financial support from The Alex J. Ettl Foundation, the Robert Lehman Foundation, the Dedalus Foundation, Inc., the National Academy's Lucelia Fund for Publications, the Bonnie Cashin Fund, and the Cape Branch Foundation. For their contributions we also thank one anonymous donor, Mr. and Mrs. John Schobel IV, Messrs. John Schobel V and Daniel Dean Schmeder, the Anita Shapolsky Gallery, the Mersky Family Foundation, the Greenberg Van Doren Gallery, the Fifth Floor Foundation, Mr. and Mrs. Maurice Katz, the Katharina Rich Perlow Gallery, and Dorothea Rockburne.

I want to acknowledge and compliment Marshall Price, now Associate Curator of Modern and Contemporary Art, who conceived of this project and brought it to successful fruition. We are also fortunate in having an outstanding support staff, to whom Marshall and I give our heartfelt thanks: Paula Bartel, Development Associate; Charles Biada, Director of Operations; Eric Blomquist, Director of Special Events; Janezee Bond, Curatorial Intern; Jonah Ellis, Building Manager; Monica Griesbach, Associate Conservator; Lucie Kinsolving, Chief Conservator; Anna Martin, Registrar; Paula Pineda, Associate Registrar; Jean Telljohann, Director of Development; Kristine Widmer, Curator of Education; and Christine Williams, Director of Communications.

We heartily appreciate the artists on the Exhibition Committee (2005–2006) who enthusiastically approved this exhibition: David Kapp, Chair; Stephen Antonakos, Larry Fane, Sonia Gechtoff, Barbara Grossman, Richard Haas, Robert Kushner, and Susan Shatter, ex-officio as well as all of the participating National Academicians.

This book was beautifully designed by the talented Rita Lascaro; printed by the ever accommodating John Schmitt of Evergreen+Central; and skillfully edited by Elizabeth Monroe. We appreciate their expertise.

Annette Blaugrund

This project has its genesis in a conversation I had with an emerging artist who asked if the National Academy was "that figurative place." After investigating the veracity of this statement, I discovered that many Academy members are abstract artists, and that the institution's collection covers a broad range of abstract styles. It is therefore with pleas-

ure that I can now answer, with this exhibition and catalogue, that the Academy is indeed much more than "that figurative place."

Even an exhibition of modest size requires the efforts of dozens of people and two in particular deserve special mention. This entire project could not have been realized without the continued encouragement, feedback, and indefatigable fundraising efforts of Annette Blaugrund, Director of the National Academy. Additionally, I am honored that Jules Olitski, to whom this catalogue is dedicated, wrote an eloquent foreword only weeks before his passing.

Many people outside the National Academy also assisted greatly in the organization of this exhibition and catalogue. These include: Laura Beiles, Associate Educator, Museum of Modern Art; Jacopo Benci, Assistant Director Fine Arts, The British School at Rome; Avis Berman; John Caperton and Philip Mott of Locks Gallery, Philadelphia; Deborah Cullen, Director of Curatorial Programs at El Museo del Barrio; Betty Cuningham Gallery, New York; Media Farzin-Rad; Anna Lovatt; Manny Silverman Gallery, Los Angeles; Dorothea Rockburne; Barbara Rose, who provided valuable insight into the essay; Don Voisine, President of the American Abstract Artists; Lisa Williams, Administrator and John Driscoll, PhD, Babcock Galleries, New York; and Nadine Witkin.

The contributors to the catalogue Cindy Medley Buckner and Monica Steinberg also deserve special commendation for their assiduous research which has brought to light new aspects of so many works in the exhibition. I would also like to mention the people who deserve the greatest acknowledgement of all: the National Academicians. They are undeniably the institution's most important resource. Past presidents and committee members Gregory Amenoff, Edward Betts, Everett Raymond Kinstler, and Paul Resika all shared their institutional recollections with me. Finally, I am grateful to all of the artists in the exhibition who were so generous with their time in speaking with me about their work. It was, in itself, an invaluable education.

Marshall N. Price

Introduction

ANNETTE BLAUGRUND

*The broad reaction against an existing art is possible only on
the ground of its inadequacy to artists with new values and
new ways of seeing.*

—Meyer Schapiro[1]

At any given moment in time, due to changing technical, political, social, and cultural
events in the world, new aesthetic choices become available. The responses to the
aftermath of World War II, for example, drove artists to seek new directions. Between
1947 and 1951 many artists working in an Abstract Expressionist mode developed and
received recognition for their innovative, creative ideas. Abstract Expressionism for them
meant freedom of expression, the challenges of new possibilities, fresh daring approaches,
and the manifestation of personal perceptions and experiences. These artists were passion-
ate about their work and willing to withstand hardship in order to attain their goals. New
York School painters Jackson Pollock, Willem de Kooning, Barnett Newman, and Mark
Rothko were revered and played a significant role in influencing a second generation—
Larry Rivers, Helen Frankenthaler, Joan Mitchell, Jules Olitski, and Robert Rauschenberg,
among others, all of whom were ultimately elected to the National Academy. During the
1960s yet another generation of artists brought in Pop art, Op art, Minimalism, and Con-
ceptual art, and some of them also became National Academicians.

The Abstract Impulse is an exhibition drawn from the Academy's collection of abstract
works that reveals interesting surprises and fills in some gaps in the art historical literature.
In fact, so many abstract artists are currently National Academicians that not all of them
could be represented in this show. Conversely, we have included work by several artists for
whom abstraction was an impermanent style, because it was emblematic of important
aspects of abstraction. Marshall Price in the following essay will explain what was happening
at the National Academy of Design (now doing business as the National Academy Museum
and School of Fine Arts) during this exciting fifty-year period of artistic breakthrough.

No history of American art of the nineteenth and early twentieth century can be told
without mentioning the Academy. The institution's history has been documented in several
publications, first by Thomas Seir Cummings' *Historic Annals of the National Academy,
1825–1863* (1865), then by Eliot Clark's *History of the National Academy, 1825–1953*
(1954), then in catalogues of the permanent collection, *Next to Nature* (1980) and *Artists
by Themselves* (1983), and further updated in *An American Collection* (1989) and most
recently in, *Paper Trail* (2000), *Challenging Tradition: Women of the Academy 1826–2003*
(2003), and Volume I of our collection catalogue 1826–1925 (2004).

Founded in 1825 by revered masters Samuel F. B. Morse, Asher B. Durand, Thomas Cole, and others who were rebelling against their elders, the National Academy of Design became the guardian of standards and taste for American art in the nineteenth century. Its mission was to exhibit and teach art and it accomplished these goals by establishing an art school and renting galleries in which to show contemporary art. Academicians are professional artists elected by their peers in the categories of painting, sculpture, print-making, and architecture. Until 1994 they first became Associates (ANA), at which time they donated a portrait of themselves to the Academy. Upon election as full National Academicians (NA), members contribute representative examples of their work. These requirements have formed the Academy's outstanding holdings of over seven thousand works of art, including one of the world's largest collections of portraits of American artists. To properly care for, exhibit, and house this collection, an accredited museum was established in the 1980s in the Beaux-Arts mansion donated to the organization in 1940 by Archer Huntington and his wife, sculptor Anna Hyatt Huntington, NA. To this end, the National Academy Museum organizes exhibitions that travel to venues across the country, hosts exhibitions from other museums, and continues to organize Annual Exhibitions of contemporary art as it has, without interruption, for 182 years.[2] These Annual Exhibitions displayed the work of Academicians along with that of emerging and established non-Academicians and, for many years the Annual was the primary place to see contemporary American art.

Unfortunately, prevailing conservative attitudes within the Academy did not recognize modernism in a timely fashion; therefore by the mid-twentieth century the institution was thought to be moribund. Yet, if the Academy's inability to change quickly led to a failure to adjust promptly to new ideas, it has also been its strength in terms of longevity and persistence. The radicals of one generation have often times become the scions of the Academy in subsequent years. Presently, the Academy does not reject artists on a stylistic basis; but represents artists who work in innovative and exciting ways in the mostly traditional mediums of painting on paper or canvas, sculpture of all materials, printmaking, and architecture. In recognition of the increasingly heterogeneous art world and the multiple means of producing visual images, the Academy is now more open to new ideas and media. As the creativity of artists is born out of tradition, not in spite of it, the Academy strives to remain vital to the dynamic world of art. Governed by a board of artists called the Council, and assisted by an Advisory Board and professional staff, the Academy is uniquely defined by the close working relationship between the artists, the Advisors, and the staff. While remaining true to our academic past by reintroducing recent art history, we are simultaneously learning to appreciate new forms of expression in the twenty-first century.

NOTES

1. Meyer Schapiro, *Modern Art: Nineteenth and Twentieth Centuries* (New York: George Braziller, 1978), 189.
2. Because of spatial constraints, Academicians now show every other year and non-Academicians in alternate years.

Abstraction at the National Academy

MARSHALL N. PRICE

> *At a certain moment the canvas began to appear…as an*
> *arena in which to act—rather than as a space in which to*
> *reproduce, re-design, analyze or "express" an object, actual or*
> *imagined. What was to go on the canvas was not a picture*
> *but an event.*
> —Harold Rosenberg, "The American Action Painters"[1]

When Abstract Expressionism, characterized by critic Harold Rosenberg as "action painting," was ascending to prominence, the National Academy of Design, an institution that had become prejudiced against pioneering artistic achievements, reacted against it. The dominant aesthetic paradigm was shifting away from representational art and toward one of complete abstraction as modernism, in the form of Abstract Expressionism, found its footing by the early 1950s. It was not universally embraced, however, and for ideologues and conservative institutions alike it became a cause célèbre.

National and international annual and biennial exhibitions were popular during the '50s and often presented new work. In addition to the best-known ones at the Whitney Museum, the Art Institute of Chicago, the Carnegie Institute, the Venice and São Paulo biennials, and the National Academy of Design, many other institutions realized similar exhibitions, including the University of Illinois and the California Palace of the Legion of Honor. Most embraced, or at least acknowledged, the aesthetic change by including experimental abstract art. The 1950 Venice Biennale, for example, included small solo exhibitions by Jackson Pollock, Willem de Kooning, NA elect, Arshile Gorky, and others, while throughout the '50s the University of Illinois included major New York School paintings alongside representational work by lesser-known artists. The National Academy, with one of the oldest annual exhibitions, however, tread much more cautiously into the arena of modern art.

Action and Reaction

In 1952, possibly in response to increasing charges of reactionism, the Academy held perhaps its most progressive annual exhibition. Emily Genauer, art critic for the *New York Herald Tribune*, noted that in spite of the generally conservative tenor of the exhibition, it did include a "handful of semi-abstractions."[2] Genauer's colleague at the *New York Times* was more generous in acknowledging this shift: "Eloquent testimony to the liberalizing winds of change that have breathed gently upon the National Academy in recent years is to be recognized in the current 127th annual exhibition in the Academy Galleries."[3] These changes, modest though they were, suggested potential progress at the venerable institution and a new direction for an organization that had come to be seen by many as retrograde and

anachronistic. Instead, however, this flirtation with modernism was ephemeral and soon elicited a reactionary response from the Academicians.

Reactionism was nothing new at the National Academy. Its roots can be traced back to the 1870s when a group of artists, protesting its conservatism, broke away to form the Society of American Artists. In 1907 Robert Henri, NA, leader of the Ashcan School, withdrew his paintings from consideration for the Annual exhibition for the same reasons.[4] Six years later, anti-modern sentiments were voiced again, this time by conservative Academician Kenyon Cox. In response to the seminal Armory Show, which effectively introduced America to European modernism, Cox published a lengthy condemnation in the *New York Times*, asserting that, "The modern tendency is to exalt individualism at the expense of law. The Cubists and Futurists simply exhibit a very extreme and savage form of this individualism, an individualism exaggerated and made absurd for the sake of advertising."[5] Conservatism persisted throughout the 1920s, '30s, and '40s, and the institution became increasingly hermetic. Election of new artists into the Academy began to dwindle, resulting in a steep decline in membership.[6]

The first year an abstract work received an award in the Annual exhibition was 1952, evidence, perhaps, of the aforementioned "liberalizing winds." Alessandro Mastro-Valerio, ANA,

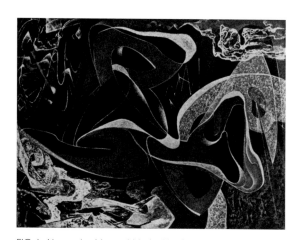

FIG. 1. Alessandro Mastro-Valerio, *Motif in a Seascape*, ca. 1952, etching.

a little-known portraitist and printmaker from the Midwest, entered what was likely the first abstract work exhibited at the National Academy. His biomorphic print, *Motif in a Seascape* (fig. 1), is anomalous in his oeuvre and nevertheless won the Cannon prize for graphic art. Additionally, its reproduction in the catalogue almost certainly contributed to the protest voiced by fellow Academician and printmaker, Roi Partridge: "I have just received the 1952 catalogue. What happened? Are we backsliding on our ideals? Some of the reproductions are the same old weary stuff that the 'progressives' (Heaven help the name) have been showing for years—now are we to take it up? Why? . . . From my point of view it would be infinitely better to stick to conservatism—and be proud of it."[7] The following year's Annual included even fewer abstract works and was noted by art critic Howard Devree in the *New York Times* for its conservatism.[8] It was, however, the first year that an abstract artist was nominated for membership. Will Barnet, NA, was proposed as Associate National Academician in the printmaking class despite the fact that he had been moving ever increasingly toward an abstract style during the 1940s. By 1953 the artist had completely disengaged from representation in his work and was consequently denied membership until twenty years later by which time he was working primarily in a stylized representational mode.[9]

While the National Academy began to turn its back on abstract art, it also inadvertently helped to nurture it. In 1953, a young painter named Richard Anuszkiewicz, NA, working in an Edward Hopper-esque representational style, was awarded the Pulitzer Trav-

eling Scholarship by a jury of Academicians.[10] Instead of using the money to travel to Europe as had many recipients, Anuszkiewicz chose to attend graduate school at Yale University, where he studied under Bauhaus artist Joseph Albers. Albers's ideas on color and his geometrically based abstraction would have a lasting effect on Anuszkiewicz's work, which became increasingly abstract during the mid-1950s.[11] Apart from the occasional and certainly unintentional fostering of future abstract artists, however, the institution was clearly grappling with the advent of modernism. Architect and President (1950–1956), Lawrence Grant White, NA, reported to the general membership that, "We are producing the kind of art that is understood and liked by the general public, it is not the kind of art that finds favor with the critics and with the self-styled 'avant-garde.'"[12] White's solution was to encourage a specific aesthetic agenda: "They [the avant-garde] also have a lot of money and an attractive, centrally located outlet in the Museum of Modern Art.... All our energies should be directed to the positive advancement of representational art."[13]

This hostile attitude toward abstract art continued throughout the decade and even intensified under the subsequent presidency of landscape painter Eliot Clark (1956–1959). Clark disingenuously maintained that the Academy had no aesthetic policy, and rather it was solely the undue amount of influence wielded by critics, scholars, and museum directors to which the Academy objected. Couching his criticism of modern art in such rhetoric, Clark, in his first presidential report to the membership explained: "To appreciate the work of art one must see it, not read about it. Yet opinion is governed more by the work than by the vision.... This is particularly pertinent to the cult of abstraction. When a picture has no meaning, critics can give it any meaning they like. The art of obfuscation reigns supreme."[14] Two years later Clark drafted a letter of protest to the Department of State. He objected to the exclusion of artists from the committee that chose painting and sculpture for the American Pavilion of the 1958 Brussels World's Fair. The display included work by seventeen artists under the age of forty-five and was a showcase for Abstract Expressionism. While the installation was not without criticism from other camps, Clark's aggressiveness reads more like an indictment of the movement itself: "It is apparent that the exhibitions of American Art sent abroad represent only a passing trend of so-called abstraction, patronized and promoted by the committees in charge. This is not only basically undemocratic, but gives a false picture of the vital achievement and variety of current art in the United States and exposes its culture to unjust and unfavorable criticism."[15]

These events occurred, ironically, at a moment when many future Academicians were exploring the creative potential of abstraction. Bernard Brussel-Smith, NA, was working at the experimental print workshop Atelier 17 with Stanley William Hayter at that time, Milton Resnick, NA, James Brooks, NA elect, and others were involved in the Club, and sculptor Philip Pavia, NA, was just about to launch *It Is*, a journal championing abstract art. However, for the remainder of the decade, despite the promising Annual in 1952, abstraction was rarely shown at the Academy. The institution's conservatism reached its apex in 1961 in the form of a Constitutional Committee charged with amending the Academy's governing charter. The committee proposed a number of innocuous procedural changes regarding the nomination and election of members, but it was the addition of a "Loyalty

to Country" clause that resonated beyond artistic boundaries: "(B) Artists known to have invoked the Fifth Amendment in reference to subversive activities shall not be eligible for Academy membership. (C) Associates or Academicians who may have invoked the Fifth Amendment in reference to subversive activities shall be expelled from the Academy.... (E) The N.A.D. shall follow the decisions of Congress and the United States Supreme Court in reference to the Smith Act and other possible future acts connected with subversion."[16] In the end, the vote by the members, while almost evenly divided, failed to get the necessary two-thirds majority and was defeated.

Refuge from Modernism

Throughout the 1960s, the National Academy dug its conservative heels in even deeper and continued to stick close to its representational roots. Very few abstract or semi-abstract, non-Academician artists participated in the Academy's Annuals during these years, and the membership continued to atrophy. Those elected to membership generally worked in a representational style of utmost conservatism and traditionalism. The institution still refused to embrace the abstraction of Mark Rothko, Barnett Newman, and other New York School painters of the previous decade, let alone the current Post-painterly abstractions of Sam Francis, NA elect, Helen Frankenthaler, NA, Frank Stella, NA elect, and Jules Olitski, NA. A large number of representational non-Academicians participated in the annual

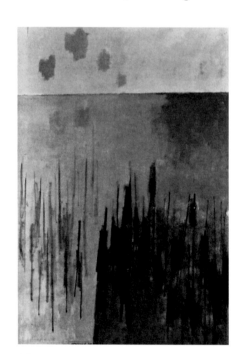

FIG. 2. Herman Maril, *Cat—Tails*, ca. 1966, oil on canvas.

exhibitions during these years, however, many of them worked in a Social Realist or Surrealist style—much more palatable to the Academicians than abstraction—including Philip Evergood, ANA, and Jules Kirschenbaum, NA. Occasionally, an acceptable middle ground was found in the works of semi-abstract artists such as Karl Knaths, NA, and Herman Maril, NA (fig. 2). Particularly revealing of current attitudes within the Academy is the dialectical manner in which architect Edgar I. Williams, NA (President 1962–1966), characterized the state of contemporary art: "We are all conscious of the tensions which exist between the two major groups in the arts—call them the moderns and the conservatives. They stand like armies facing one another constantly trigger-happy for engagement.... Our strength is our background. We must be proud of it, not ashamed of the past, as seems to be a tendency prevalent among many critics and the hue and cry of 'way out' modernists."[17]

This protracted denial of contemporary trends and steadfast refusal to acknowledge that the Academy no longer reflected the state of contemporary American art caused the institution to lose much of its prestige. By the mid-1960s abstraction had transcended the gestural works of Abstract Expressionism and now included the reductive geometries of Minimalism, the perceptual explorations of Op art, and idea-based Conceptual art. It was a moment of pluralism that only fueled Williams's myopic belief that the Academy must serve as a beacon of

past achievements. Indeed, one critic described the Annual of 1965 as a "refuge from the almost total confusion that had overtaken modern art." [18] Even those who were not sympathetic to the most recent artistic developments were highly critical of the Academy. In 1966, for instance, John Canaday was brutally forthright in his assessment of the Annual: "The fourth-floor galleries hold some technically impeccable water-colors as a good start to a show that gets worse (or maybe you just get more tired) as you work your way down to the front door, or escape hatch." [19] For the rest of the 1960s, due perhaps in part to the reemergence of representational styles such as Photorealism, the debate over modernism versus conservatism among Academicians seemed to subside. And while there was continued acknowledgement within the institution that it had to attract younger members in order to survive, little was done in this regard until the following decade.

During the 1970s, abstract art was shown only intermittently at the National Academy, and the exhibitions continued to remain overwhelmingly representational. Abstract artists slowly began to enter into membership, but by this time the institution had dug such a deep trench in defiance of modern trends that it very nearly served as its grave. Reviews of the Annual were filled with acerbic candor: "The academy's doleful annual shows long ago stopped being worth a review, although a stock paragraph could be kept on hand for use as an occasional courtesy, commenting on the technical proficiency and illustrational banality of the top quarter of the show, the amateurism of most of it, [and] the ludicrousness of whatever efforts were made to meet head-on whatever innovations were current before World War I." [20] The Academy's regressive tendencies now threatened its very future. Clearly, a new direction was needed to bring the institution into the twentieth century.

While non-member artists had always participated in the annual exhibitions, they were at the mercy of a jury of Academicians, whose taste was generally conservative. The work chosen was therefore often figurative. In 1970, at the urging of Umberto Romano, NA, then chairman of the Exhibition Committee, a group of non-member artists was invited to participate in the Annual the following year, exempt from jury review. [21] Stephen Greene, NA, Conrad Marca-Relli, and Mark Tobey, ANA elect, were among the prominent abstract painters invited, as well as leading representational artists such as Paul Cadmus, NA, Richard Estes, NA, Gregory Gillespie, NA, Alice Neel, NA elect, Philip Pearlstein, NA, and Fairfield Porter. [22] It was hoped that these artists could bolster the exhibition, help it more accurately reflect some recent trends in contemporary art, and ultimately regain some recognition for the institution. While it certainly did not include any radical or experimental work, the general tenor of the exhibition was beginning to change. Frank Gelletin reported in *The Sunday Star*: "Ideology aside, you will do yourself a distinct disservice to be in New York . . . and not take in the academy annual. You can get your futuristic jollies next door at the Guggenheim's International, but you can see good pictures and statues at the academy." [23]

Including works by more progressive artists in the Annual was a commendable first step by the Academy, but it was far from bringing the institution completely up-to-date. In fact, the "futuristic jollies" at the Guggenheim to which Gelletin was referring was an exhibition of twenty-one of the most forward-thinking international artists who represented movements such as Minimalism, Conceptualism, and Arte Povera. The exhibition included work

by Daniel Buren, Dan Flavin, On Kawara, and Mario Merz, among others, but was nevertheless lambasted by the *New York Times*. Apparently, art critic John Canaday was an equal opportunity detractor and, recalling his review of the Academy's show only a few years earlier, he put forth that: "The most boring presentations are those conceptual pieces in which one is offered nothing but reading matter, adding *déja lu* to the oppressive sense of *déja vu* that characterizes the rest of the show." [24]

In 1973 and 1974 an even greater number of abstract artists were invited to participate in the annual exhibitions, also exempt from jury review. Many were members of the New York School, while others worked in alternative abstract styles. They included, Pat Adams, NA, Josef Albers, Richard Anuszkiewicz, NA, James Brooks, NA elect, Willem de Kooning, NA elect, Sam Francis, NA elect, Helen Frankenthaler, NA, Adolph Gottlieb, Philip Guston, ANA elect, (then working figuratively), Al Held, NA elect, Paul Jenkins, NA, Jasper Johns, NA, Norman Lewis, Joan Mitchell, ANA elect, George L. K. Morris, Robert Motherwell, ANA, Robert Rauschenberg, NA, and Theodore Stamos, NA elect. [25] Ironically, all of these artists, with the exception of Albers, Gottlieb, Lewis, and Morris, would eventually be elected into membership in the Academy. Despite this infusion of abstraction—relatively progressive work for the Academy—and the addition of notable representational artists that included Benny Andrews, NA, Leland Bell, ANA elect, Alex Katz, NA, Lester Johnson, NA, and Wayne Thiebaud, NA, Canaday completely snubbed both of the exhibitions, feeling perhaps they were not even worthy of the "stock paragraph" to which he referred a few years earlier.

By the early 1970s many artists had been exploring the expressive possibilities of new mediums such as performance, video, and installation art—all anathema to the Academy's dedication to traditional media. As a result, some critics had mistakenly declared painting essentially dead. It continued, however, very much alive during this period and even incorporated some of the characteristics of these new mediums. [26] The National Academy, not surprisingly, chose to ignore these new developments and, as indicated by the invitees to the Annuals, was still playing "catch-up" from the previous twenty years. Despite the recent addition of abstraction to the Annuals, only a handful of abstract artists were elected to membership during the decade. They were the first and included Gyorgy Kepes, NA (ANA, 1973), Gabor Peterdi NA (ANA, 1974), Jimmy Ernst, ANA (1977), and Leo Manso, NA (ANA, 1979). [27] The coming decade, however, would finally signal a permanent change for the institution that had for so long been perceived as a bastion of conservative, exclusively figurative art.

Better Late than Never

Even though the Annual Exhibition in 1980 was nearly completely lacking in abstract art, the year marked an important change in artist membership. In his remarks to the Academicians at the general meeting, architect Robert Hutchins (President, 1977–1989), raised some serious questions regarding the Academy's relevance in an increasingly fluid art world. Hutchins acknowledged the importance of the institution in the history of American art, but asked if its initial mission of training artists and exhibiting contemporary work was still pertinent in the eyes of the membership and the general public. It was, for the first

time, a moment of self-reflective evaluation and a relinquishment of the steadfast defensiveness against new directions that had persisted for decades. Hutchins asked, "Do the members of the Academy feel that in recent years the Academy has been too conservative? If so, is this because of the nature of the work submitted by the artist members and by jury selection? ... Those who are familiar with the Academy tend to think that it is traditional oriented and perhaps somewhat moribund. Is it not important that efforts be made to alter this image?"[28]

Hutchins's remarks were, in essence, a reminder to the members that the institution *was* seen as retrograde and that it was necessary to reevaluate its position in the art world. That year, perhaps partially in response to these questions and the repeated criticisms of retrenchment and recidivism of years earlier, the Membership Committee nominated a large group of predominantly abstract artists for Associate membership. Many of these nominees were first-generation Abstract Expressionists who had previously been invited to exhibit in the Academy's Annual. The group included James Brooks, NA elect, Willem de Kooning, NA elect, Stephen Greene, NA, Philip Guston ANA elect (working representationally then), Milton Resnick, NA, Esteban Vicente, NA, Vaclav Vytlacil, ANA, and Hale Woodruff, ANA.[29] The entire group of artists easily passed the balloting when voted on by the general membership, ostensibly heralding a new era at the National Academy. The change would not come so easily, however. The following year, and perhaps in reaction to the previous ballot, not a single abstract artist was nominated for membership.

While the vociferous debates over the "moderns" versus the "conservatives" had subsided, members continued to perpetuate an aesthetic divide between figuration and abstraction, as well as the place of the latter within the Academy. This gulf was reflected in the ebb and flow of abstract artists elected to membership during these years of change. Furthermore, despite the reemergence of figuration in the late 1970s and early 1980s, albeit in the abstracted forms of Neo-Expressionism, the Academy again chose to ignore this new development. In 1982, Wolf Kahn, NA, recently elected to serve on the Council, called for the elimination of this aesthetic rift and for the Academicians to vote on new members based solely on merit. Kahn implored his colleagues to reject cronyism, which had long been a part of the institution, and "to represent in those votes the tradition of the Academy which was to be the gathering place for those artists who have gained truly national recognition, whose work, of whatever tendency, enjoys a consensus for quality among artists."[30] That year, abstract artists Robert Motherwell, ANA, Richard Pousette-Dart, Robert Rauschenberg, NA, and Jack Tworkov were nominated, although of this distinguished group, only Rauschenberg was elected. Eight years later, Motherwell, too, was elected, but Pousette-Dart and Tworkov were never awarded membership.[31]

Kahn's sentiments were echoed in 1984 by John Dobkin (Director, 1979–1989), in his introduction to the 159th Annual Exhibition catalogue. For the first time, a nonartist contributed to the discourse and raised some serious concerns about the direction of the institution: "Must he [the artist] come from a figurative background? Must he work with a representational mode in order to 'fit in'? One group of members believes that a preference for the figurative is a precondition to election. The opposing group believes that the

maturity of the artist and recognition of excellence by his peers are the only standards to be applied."[32] Dobkin's answer was clear: "Only one criterion should be applied in considering an artist for membership—achievement."[33] Despite the initial groups of abstract artists elected in 1980 and 1982 and the calls of Hutchins, Kahn, and Dobkin, representational work continued to dominate the remaining annual exhibitions of the decade. The exhibitors were mostly Academicians, and while nonmembers continued to be invited exempt from jury review, their numbers remained fairly low.

During the 1990s, the institution continued to have trouble shedding its conservative image. In his Foreword to the catalogue of the 1990 Annual, for instance, sculptor Richard McDermott Miller (President, 1989–1992) reflected the larger ideological rift to which Dobkin had earlier referred and made it abundantly clear on which side he stood. Miller's statement opens, "At a time when it is fashionable for artists to be outrageous, the National Academy of Design takes pleasure in being outrageously unfashionable. In mounting the 165th Annual Exhibition, we have willingly ignored current fashion."[34] Miller's retrogressive efforts did not go unrecognized, for, as the *Times* reported, "Few of the artists will be familiar to even the most diligent habitué of the New York gallery scene. Nor is it an index of mainstream styles."[35] Critics occasionally singled out the few abstract artists who did exhibit during the early 1990s, but identified their works as exceptions among otherwise retrograde styles: "If on the whole abstraction is in short supply…many other historical styles are represented."[36]

While 1992 was another year in which abstraction was mostly lacking from the Annual, membership expanded significantly when sixty-three painters and thirteen sculptors—a good portion of them abstract artists—were nominated for Associate membership.[37]

FIG. 3. Michelle Stuart, *Seed Calendar: ANDH,* 1993, seeds on China paper, 18 × 18⅜ inches, ANA diploma presentation, 1996, © 1993 Michelle Stuart.

Throughout the remainder of the decade, abstract artists continued to be elected to membership, and as the number increased, so too did the number of abstract works included in the annual exhibition. In 1994, the membership amended the constitution thereby eliminating the Associate level of membership. Subsequently, all Associate members were automatically elevated to full membership. This change streamlined an anachronistic system that had made it difficult to elect new members and allowed for an even greater number of nominees. That year Michelle Stuart, NA, was elected to Associate membership and shortly thereafter elevated to full membership. Stuart is one of the few Academicians who is associated with Conceptual and post-Minimalist movements of the 1970s. Her diploma presentation, *Seed Calendar* (fig. 3), exhibits the artist's particular interest with natural history, vegetation, and cosmology.[38]

It was also in 1994 that the Academy began a series of exhibitions chosen by prominent artist members from the institution's collection. In his review of the inaugural "Artist's Eye" exhibition (curated by Academician Wayne Thiebaud, NA), art critic Hilton Kramer

FIG. 4. Stanley Boxer, *Silverheatscaught*, mixed media on canvas, 19 x 50 inches, NA diploma presentation, 1992, Art © Estate of Stanley Boxer/Licensed by VAGA, New York, NY.

noted that the National Academy had eschewed its categorical opposition to modernism, a defining characteristic of the institution that for so long had been the topic of debate among the members. While the Academy was not exhibiting the most radical of recent art, according to Kramer, it instead offered "an alternative to the kind of anti-art agenda that dominate most of our other museums specializing in contemporary art."[39] It was, however, with an installation of recent acquisitions that the journalist was most impressed—an exhibition dominated by abstract work of recently elected artists, including Stanley Boxer's *Silverdheatscaught* (fig. 4), Joseph Fiore's *Pentahedron* (fig. 5), and Leon Goldin's *Wind and Smoke* (fig. 6). Kramer wrote: "Interestingly...it is the abstract and semi-abstract paintings, rather than the representational pictures, that are by far the most accomplished."[40] Abstraction had arrived at the Academy at last.

For the remainder of the 1990s, more and more abstract artists were elected to membership and subsequently exhibited in the annual exhibitions. Many had been invited to show in the Annual prior to their nominations, including, for instance, Tom Boutis, NA, who exhibited in the 167th Annual in 1992 and George Ortman, NA, an artist who had been

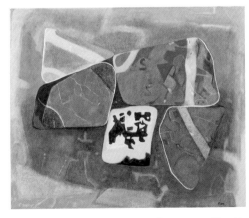

FIG. 5. Joseph Fiore, *Pentahedron*, oil on canvas, 38 x 46 inches, ANA diploma presentation, 1993, © 1993 Joseph Fiore.

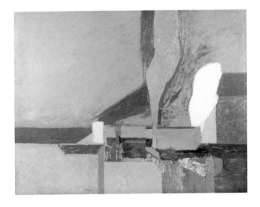

FIG. 6. Leon Goldin, *Wind and Smoke*, 1971, oil on canvas, 50 x 66 inches, NA diploma presentation, 1993, © 1971 Leon Goldin.

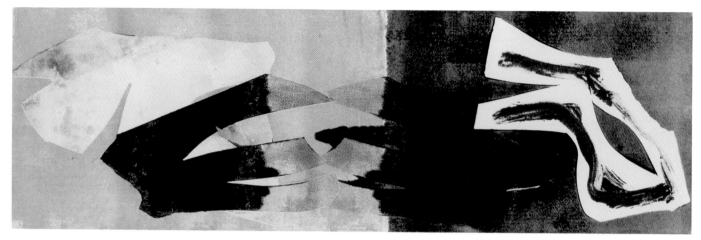

FIG. 7. Tom Boutis, *Untitled*, 1982, oil monotype on cream wove paper, 16 × 26⅛ inches, NA diploma presentation, 1995, © 1982 Tom Boutis.

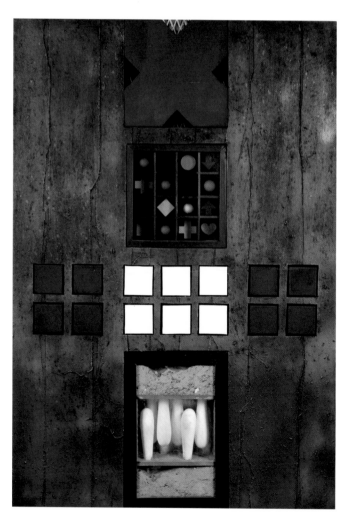

FIG. 8. George Ortman, *Urban Renewal*, 1995, wood and mixed media, 60 × 41½ × 5¼ inches, NA diploma presentation, 1995, © 1995 George Ortman.

FIG. 9. Paul Jenkins, *Phenomena, Blue Reach*, 2002, arcylic on canvas, 25⁹⁄₁₆ × 21¼ inches, NA diploma presentation, 2007, © 2007 Artists Rights Society (ARS), New York / ADAGP, Paris.

FIG. 10. Sam Gilliam, *Frieze* (detail), 1983, acrylic on nine canvases, 25 x 376 inches (overall), NA diploma presentation, Gift of Lionel C. Epstein, 2001, © 2001 Sam Gilliam.

working with geometric forms since the 1950s. Boutis's diploma presentation, an untitled monotype (fig. 7), uses totemic shapes combined with both gesture and geometry to create a unique abstract vocabulary. Ortman's diploma presentation, *Urban Renewal* (fig. 8), is a three-dimensional construction that combines painting and sculpture. In 1997, Paul Jenkins, NA, who had been invited to participate in the Annual in 1974, was elected to the Academy. His diploma presentation, *Phenomena, Blue Reach* (2002; fig. 9), is a late work that illustrates the artist's exploration of abstraction for more than fifty years. Exhibiting in the Annuals marks, for many artists, the first steps toward membership in the Academy.

Contemporary Academy

By the year 2000, Academicians began electing more and more abstract artists who had achieved national and international renown even if they had not exhibited at the Academy. Sam Gilliam, NA, for example, known for his abstract draped canvases, was elected to membership in 2001. His multi-paneled painting, *Frieze* (1983; fig. 10), came as his diploma presentation through the generosity of a third-party donor. The new millennium also brought a major change in the Annual itself. In 2002, under the leadership of President Gregory Amenoff, the Academy's Annual exhibition was, for the first time in the institution's history, a juried Invitational of nonmembers. A small group of prominent artists were invited to participate exempt from jury review, while the remaining artists were invited to submit work, which was then juried by a committee of Academicians. While the exhibition struck a balance between representational and abstract work, it included ninety-six multigenerational artists, such as Dorothea Rockburne, NA, and Robert Mangold, NA, who had worked with a vocabulary of abstraction for decades.[41] Further, a large number of established abstract artists who did not necessarily exhibit in the Invitational were elected to membership in 2002. These included William Scharf, NA (fig. 11), and Knox Martin, NA (fig. 12), both of whom combine gesture and geometry in their painting, the enigmatic constructions of Lawrence Fane, NA, and the starkly geometric metal and stone works of William Crovello, NA. The diversity of these artists' styles reflects a variety of movements and influences and also pointed toward renewed interest in the viability of abstraction on the part of the Academy.

The invitational exhibitions continue to be a forum in which artists can show their work among a pluralism of styles. Abstraction has been prominent in the subsequent two invitational exhibitions, and in 2004 the work ranged from the mixed-media installations of Polly Apfelbaum and Tara Donovan, to the reductionist geometry of Sol Lewitt, NA elect,

FIG. 11. William Scharf, *Anointed Crook*, 1998, acrylic on board, 12 × 14⅞ inches, NA diploma presentation, 2003.

FIG. 12. Knox Martin, *Eel Flask and Grapes*, 2000–2003, acrylic on canvas, 50⅞ × 45½ × 1⅜ inches, NA diploma presentation, 2003, Art © Knox-Martin/Licensed by VAGA, New York, NY.

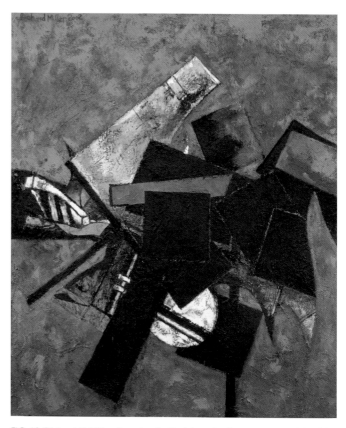

FIG. 13. Richard K. Miller, *Assault*, oil, oil stick, and collage on canvas, 70 × 58 inches, NA diploma presentation, 2006, © 2002 Richard K. Miller.

to the gestural paintings of Melissa Meyer and Bill Scott, to the Neo-Constructivist works of Mel Kendrick and Richard K. Miller, NA (fig. 13). The 2006 invitational exhibition included an equally impressive list of both emerging and established abstract artists, including Lynda Benglis, John Chamberlain, NA elect, and Harriet Korman, whose *Untitled* (fig. 14) had the distinction of being purchased by the Henry Ward Ranger Fund.[42] While the reviews of these Invitationals have been mixed, all have noted the openness and renewed ardor with which they were mounted. Art critic Ken Johnson, for instance, predicted that "If the trend [of improvement] continues, people could start obsessing over the invitational the way they do over the Whitney Biennial."[43] These invitational exhibitions have served both to broaden the scope of work shown at the Academy and to better represent the current state of contemporary art than previous Annuals. Most importantly, however, they have brought the institution back to one of its founding principles: to exhibit contemporary American art.

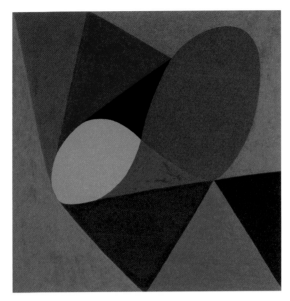

FIG. 14. Harriet Korman, *Untitled*, 2001, oil on canvas, 54 x 54 inches, courtesy Lennon, Weinberg, Inc., New York, Ranger Fund Purchase Prize.

While the debate over the viability of abstraction and its place in the National Academy began in the 1950s, lasted for decades, and finally subsided only a little more than twenty years ago, it has helped to lead the institution toward a new direction. Through the establishment of an exclusive invitational exhibition and the election of larger numbers of distinguished artists, many of whom work abstractly, it is clear that the Academy is pushing forward into a new era. This change comes at a timely moment, when many young artists are working abstractly, and the discourse over its viability has reemerged with renewed enthusiasm. In her introductory essay to the most recent invitational exhibition, Nancy Malloy observed that: "While abstraction seemed to be supplanted in the 1980s by a new figurative style, it is now coming back with a re-examination by artists normally devoted to this mode and it can be seen surfacing in the work of younger artists looking for new means of expression."[44] Unfortunately, the institution was for many years dilatory in embracing the changing aesthetic winds of American art. The twenty-first century, however, promises to be one of advancement for the National Academy. The institution has been infused with restored vigor and once again has a growing membership that embraces the pluralism that is contemporary American art, including those who work under the abstract impulse.

NOTES

1. Harold Rosenberg, "The American Action Painters," *Art News* 51 (December 1952): 22.
2. Emily Genauer, "Art Show Open at Academy of Design Today," *New York Herald Tribune*, 26 March 1952, 19.
3. Howard Devree, "National Academy: The 127th Annual Opens—Stress on Realism," *New York Times*, 30 March 1952, sec. X, 9.
4. Henri's decision ultimately led to the breakthrough independent exhibition "The Eight" in 1908. Kimberly Orcutt, *Painterly Controversy: William Merrit Chase and Robert Henri*, exh. cat. (Greenwich, CT: The Bruce Museum, 2007), 42–43.
5. Kenyon Cox, "Cubists and Futurists Are Making Insanity Pay," *New York Times*, 16 March 1913, sec. SM, 1. In addition to being a vocif-

erous critic of modern art, Cox was an active member of the National Academy, serving continuously on the Council between 1904 and 1919, with the exception of one year.

6. In 1952, for example, only two painters were elected National Academicians: Malvin Marr Albright (also known as Zissly) and Ernest Fiene.

7. Roi Partridge to Eliot Clark, 5 April 1952, National Academy Museum Archive. Roi Partridge (1888–1984) was one of the leading American printmakers of his generation and taught for much of his career at Mills College, California.

8. Howard Devree, "National Academy Gives Art Awards," *New York Times*, 1 April 1953, 41.

9. Robert Doty, *Will Barnet* (New York: Harry N. Abrams, Inc., 1984), 51. Barnet has been an active member of the National Academy since his election in 1974, serving as recording secretary and first vice president. He continues to hold the honorary position of vice president at the age of 96.

10. The Pulitzer Traveling Scholarship was established for an art student between the ages of 15 and 30 studying in the United States. It was originally intended to be awarded by the Society of American Artists, which was absorbed by the National Academy of Design in 1907. Past recipients include Jan Matulka (1917), Henry Hensche (1923), and Jerome Witkin (1959).

11. Anuszkiewicz, who first exhibited at the National Academy Annual in 1954, would not exhibit again until 1974, when he was one of a number of artists invited by the Exhibition Committee to participate without jury review. He was elected to membership in 1992.

12. Lawrence Grant White, "President's Report," 11 February 1953, National Academy Museum Archive.

13. Ibid.

14. Eliot Clark, "President's Report," 7 March 1956, National Academy Museum Archive.

15. Eliot Clark, draft letter to the Department of State, National Academy Museum Archive. Included in the United States Pavilion exhibition Seventeen American Painters was San Francisco–based artist Sonia Gechtoff, elected NA 1993.

16. "Recommendations for Constitutional Changes," July 28, 1961; attachment to "Council Minutes," October 2, 1961, National Academy Museum Archive. The Smith Act, officially known as the Alien Registration Act (1940), required all adult noncitizens to register with the government and made it a criminal offense to attempt or to advocate for the forceful overturn of the United States government. Clause A called for the display of the American flag at all meetings of the membership, while D and F indicated that clauses B and C apply to artists who were members of subversive organizations and that the burden of proof is entirely on the artist.

17. Edgar I. Williams, "President's Report," 10 March 1965, National Academy Museum Archive.

18. Stuart Preston, "Art: National Design Academy Annual," *New York Times* 27 February 1965, 22.

19. John Canaday, "Art: For Sake of Expression, Not Esthetic Theory," *New York Times* 5 March 1966, 45.

20. John Canaday, "Art: Dissent at the Academy of Design," *New York Times* 28 February 1970, 24.

21. This practice of inviting distinguished artists to exhibit without jury review continued until 1982, after which time the exhibitions alternated yearly between a non-juried members exhibition and a juried exhibition of both Academicians and non-Academicians.

22. Balcomb Greene and Alfred Leslie, NA, also exhibited, but were both working in a representational mode. Though Conrad Marca-Relli agreed to participate, he ultimately did not exhibit because most of his work was traveling in a retrospective exhibition. David McKee to Alice Melrose, 22 January 1971, National Academy Museum Archive.

23. Frank Gelletin, "The Last Surviving Survey Show Raises Some Serious Questions," *The Sunday Star* 14 March 1971, sec. D, 1. Stephen Greene won the Andrew Carnegie Prize for his painting, *Equation of Night* and would go on to become one of the most frequent abstract artists to exhibit in the Academy's Annuals.

24. John Canaday, "Art: A 'Documentary' at Guggenheim," *New York Times* 13 February 1971, 23.

25. Of these artists, only Adams, Brooks, Jenkins, Lewis, Morris, Motherwell, and Stamos exhibited during these years.

26. Katy Siegel, "Another History is Possible," in *High Times, Hard Times: New York Painting, 1967–1975*, exh. cat. (New York: Independent Curators International, 2006), 30. The exhibition was on view at the National Academy from February 15–April 22, 2007.

27. Karl Knaths was elected to membership in 1968, but was known for working primarily in a quasi-Cubist, semi-abstract mode.

28. Robert Hutchins, "President's Report," 16 April 1980, National Academy Museum Archive.

29. Headed by E. Raymond Kinstler, the Membership Committee included John Annus, Werner Groshans, Joseph Hirsch, Hughie Lee-Smith, Frank Mason, Paul Resika, Raphael Soyer, and Jane Wilson.

30. Wolf Kahn, "Address to the General Membership," March 1982, National Academy Museum Archive.

31. Other abstract artists who were nominated preliminarily but failed to reach the balloting that year included Ethel Edwards, Edward Giobbi, NA, Emily Mason, NA, Jules Olitski, NA, and sculptors Lawrence Fane, NA, Roy Gussow, Anthony Padavano, NA, and George Tsutakawa.

32. John Dobkin, "Director's Introduction," in *National Academy of Design 159th Annual Exhibition*, exh. cat. (New York: National Academy of Design, 1984), n.p.

33. Ibid.

34. Richard McDermott Miller, "President's Foreword," in *165th Annual Exhibition*, exh. cat. (New York: National Academy of Design, 1990), 3.

35. Holland Cotter, "Contemporary Works from an Old Tradition," *New York Times* 1 May 1992, sec. C, 32.

36. Ibid.

37. The nominees included abstract artists Pat Adams, NA, Richard Anuszkiewicz, NA, Jake Berthot, NA, James Bohary, NA, Stanley Boxer, NA, Aldo Casanova, NA, Edward Dugmore, NA, Nick Edmonds, NA, Joseph Fiore, NA, Andrew Forge, NA, Robert Goodnough, NA, Sidney Gordin, NA, Bill Jensen, NA elect, Ellsworth Kelly, NA elect, Frank Lobdell, NA, Brice Marden, NA elect, Jules Olitski, NA, Beverly Pepper, Tim Prentice, Richard Pousette-Dart, Harvey Quaytman, NA, Ralph Rosenborg, NA, Tony Rosenthal, NA, Judith Rothschild, Paul Russotto, NA, Jon Schueler, NA, Theodore Stamos, NA elect, and Jack Youngerman, NA elect.

38. David Dearinger and Isabelle Dervaux, *Challenging Tradition: Women of the Academy, 1826–2003*, exh. cat. (New York: National Academy of Design, 2003), 30.

39. Hilton Kramer, "National Academy Paintings: Modernism Is Not Our Foe," *New York Observer* 9 May 1994.

40. Ibid.

41. As part of his bequest, Academician Henry Ward Ranger established the Ranger Fund in 1919 to purchase paintings by American artists. These are then distributed to public institutions throughout the country, and after seven years, the Smithsonian Institution has the right to claim the work for the Smithsonian American Art Museum.

42. Other prominent abstract artists in that show included Bruce Conner, Sally Hazelet Drummond, Louise Fishman, Thomas Nozkowski, NA elect, Pat Passlof, NA elect, Judy Pfaff, Sean Scully, James Siena, and Kenneth Snelson.

43. Ken Johnson, "The 179th Annual," *New York Times* 14 May 2004, sec. E, 30.

44. Nancy Malloy, "Looking Back, Looking Forward: The 181st Annual Exhibition," in *The 181st Annual Exhibition*, exh. cat. (New York: National Academy Museum, 2006), 10.

Catalogue

CLINTON ADAMS

(1918–2002)

ANA 1991; NA 1992

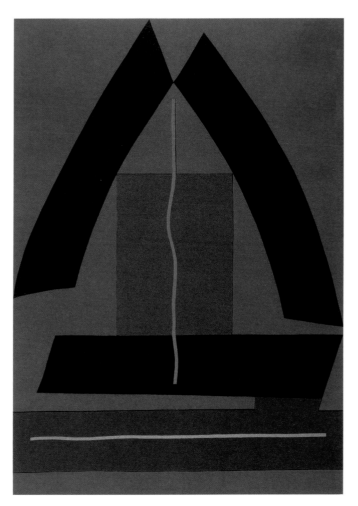

Triad VI, 1980
Color lithograph on off-white German
 etching paper
EDITION: 12/12
IMAGE SIZE: 27⅜ x 19⅝ inches
SHEET SIZE: 29½ x 21⁷⁄₁₆ inches
NA diploma presentation, 1992
© Mary E. Adams

Born in Glendale, California, Clinton Adams was a prolific painter and printmaker for more than fifty years and in 1960 served as the inaugural associate director of the Tamarind Lithography Workshop. Adams initially studied at Glendale Junior College before enrolling in the art department at the University of California, Los Angeles during the 1930s. The curriculum at UCLA at the time was traditional and based essentially on the teachings of Arthur Wesley Dow.[1] Its persistent conservatism, even after Adams became a professor there, was recalled in an interview with Van Deren Coke: "At that point in time the UCLA art department emphasized the still life, and a rather traditional, representational kind of drawing. I think all of us on the faculty then believed very strongly in that kind of discipline. The Abstract Expressionist movement was very strong elsewhere. The Berkeley department, for example, was involved with almost nothing but Abstract Expressionist ideas. The UCLA department, by comparison, seemed quite conservative."[2]

Adams served within an Engineer Camouflage Battalion during World War II and was stationed for a time at Mitchel Air Force Base, Long Island. In his spare time he would make regular trips into New York City where he saw the work of Stuart Davis and the Precisionists. These encounters had an immediate and lasting effect on his paintings and would soon be influential on his prints as well.[3] After the war he returned to UCLA in 1946 to teach in the art department. In 1950, Adams met Lynton Kistler, who introduced him to the technique of lithography, and by 1960 he was hired to oversee operations at the Tamarind Lithography Workshop. After accepting a teaching position at the University of New Mexico the following year, Adams brought the Tamarind Workshop there permanently in 1970. He would go on to oversee the (renamed) Tamarind Institute until his retirement and co-authored *The Tamarind Book of Lithography: Art & Techniques* with Tamarind's first master printer and technical director, Garo Antreasian, NA.[4]

When Adams began producing lithographs in the late 1940s, they were semi-abstract prints that were primarily cubist-inspired. By 1960 he developed a technique of applying a tusche wash to the lithography stone. This allowed him to incorporate a gestural variation of abstraction that combined elements of Abstract Expressionism with more geometric forms. By the end of the 1960s, Adams had abandoned the expressive painterly gestures in favor of simplified geometric shapes that echoed the primary forms of Minimalism. The *Venus* series was one of his earliest to utilize this geometric vocabulary, and out of it grew the *Triad* series to which this print belongs. The work is nearly identical to the painting *Triad IV* (1980; Albuquerque Museum), and, as in other works from the series, Adams uses a limited palette of colors within a composition of a broken triangle.

—MNP

1. Clinton Adams, interview with Paul J. Karlstrom, 2–3 August 1995, online transcript, Archives of American Art, Smithsonian Institution.
2. Van Deren Coke, *Clinton Adams: A Retrospective Exhibition of Lithographs*, exh. cat. (Albuquerque: The University of New Mexico Art Museum, 1979), 5.
3. Coke, *Clinton Adams*, 5.
4. Garo Z. Antreasian and Clinton Adams, *The Tamarind Book of Lithography: Art & Techniques* (Los Angeles: Tamarind Lithography Workshop, 1971).

PAT ADAMS

(b. 1928)

ANA 1992; NA 1993

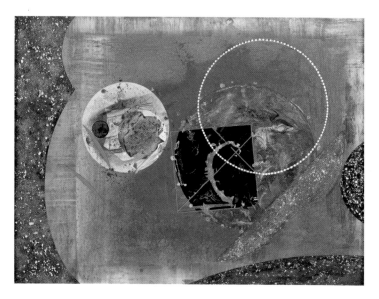

Des Clefs, 1990
Mixed media on paper mounted to canvas
15 1/8 × 20 1/4 inches
ANA diploma presentation, 1992
© Pat Adams

Pat Adams has used a complex abstract visual vocabulary to explore metaphysical ideas in her paintings and prints for decades. Growing up in Stockton, California, her earliest engagement with art came through stories of women in her family who painted in the nineteenth century and visiting the Haggin Museum, particularly its annual children's exhibition.[1] She studied at the University of California, Berkeley, receiving her BA in 1949, and attended summer sessions at the California College of Arts and Crafts (renamed the California College of the Arts), the University of the Pacific, and the Art Institute of Chicago. Most influential among her instructors at Berkeley were Margaret Peterson for her ideas on color and Worth Ryder, whose teachings prepared her to "think, to understand the terms through which one arrives at form rather than to proceed through emulating style."[2]

Adams came to New York in 1950 to continue her studies at the Brooklyn Museum Art School with instructors Max Beckmann, John Ferren, and Reuben Tam, NA. Interaction with the collections and exhibitions in New York expanded her visual literacy tremendously. The following year she traveled to Europe where she was profoundly affected by encounters with such diverse works as fifteenth-century panel paintings by Hieronymous Bosch, illuminations within the *Lindisfarne Gospels*, Turner's nearly abstract late works, and Chinese landscape paintings from the Song dynasty.[3] These influences were manifested in paintings shown in her first solo exhibition, held at the Korman Gallery (soon to become Zabriskie Gallery) in 1954. A Fulbright fellowship to study in France in 1956 enabled the artist to examine the prehistoric megaliths along the coast of Brittany. Her encounter with the Gavrinis Tumulus was particularly instrumental in addressing her interest in the genesis of visual thought at that time.[4]

Des Clefs incorporates various linear qualities combined with the textural encrustation of mixed media that the artist introduced to her work beginning in the 1970s.[5] Adams is very much interested in the components of perception and how these shape our apprehension of reality. Through her use of calculated and random items, the artist reaches into a realm of elemental interactions on both a micro- and macrocosmic scale, which yields a range of associations to natural phenomena. Adams has cited a particular interest in the notion of an "inner space" as defined by the French nineteenth-century physiologist Claude Bernard "as the equilibrium achieved to establish and necessary to maintain the entity of each species."[6] In resisting easy outside references, her works are visual propositions in which the tension of ideas of universality and specificity, outward expansion and inward exploration, achieve, in the words of Martica Sawin, "something akin to alchemical transformation, that is, an effect of process, of on-going becoming that illuminates the condition in which we exist."[7] —MNP

1. Pat Adams correspondence with author, 10 March 2007, National Academy Museum Archive, New York.
2. Robert Boyers, "'Willingness and Reverence: An Interview with Pat Adams," *Bennington Review* no. 2 (September 1978): 44.
3. Adams to author, 10 March 2007.
4. Ibid.
5. See Dan Cameron, *Pat Adams: Works on Paper*, exh. cat. (New York: Zabriskie Gallery, 1986), n.p.; Debra Bricker Balken, *Pat Adams: Paintings 1968–1988* (Pittsfield, MA: The Berkshire Museum, 1988), 15. Adams has noted that related precedents include *Inscribed Place* (1971), *Together Come Rightly Many* (1974), *Close Talk* (1976), and *Willingness* (1977–78). Pat Adams correspondence with author, 11 February 2007, National Academy Museum Archive.
6. Pat Adams correspondence with Isabelle Dervaux, 30 July 2003. National Academy Museum Archive.
7. Martica Sawin, *Pat Adams: Paintings, 1954–2004*, exh. cat. (New York: Virginia Zabriske Gallery, 2005), n.p.

STEPHEN ANTONAKOS

(b. 1926)

NA 2004

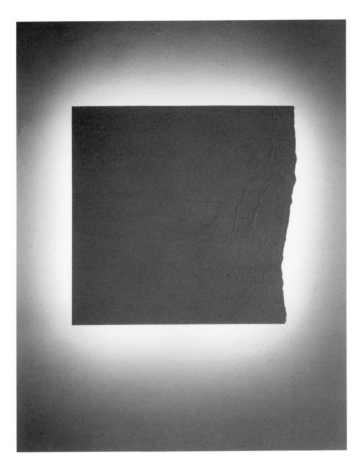

The Light, 1997
White Varathene paint on wood with neon
24 x 25 ⅜ x 4 ½ inches
NA diploma presentation, 2005
© 1997 Steven Antonakos

Neon light is the primary medium of Stephen Antonakos, and the artist has continued to explore and develop its possibilities throughout his career. Born in Greece, Antonakos immigrated with his family to America at the age of four. As a young man, he initially worked as a commercial artist but soon began to incorporate found materials in his works; one of his earliest assemblages was included in the seminal exhibition, New Forms, New Media, at the Martha Jackson Gallery in 1960. The following year Antonakos experienced a revelation while walking home from his studio one evening and was captivated by the illuminative effects of a neon sign. It was then that he decided to incorporate neon into his work, and, after beginning to experiment with it in his studio, he created his first light assemblage in 1962, entitled *White Light*.

By 1964, Antonakos was working almost exclusively with neon to create works that defy conventional definitions of sculpture. It was a time of artistic ferment when the two very different aesthetics of Pop art and Minimalism were prevalent. While adhering to neither of these movements, some of Antonakos's neon works have incorporated elements of each.[1] The artist often blurred the lines between drawing, sculpture, and installation in the late 1960s and early 1970s, as he worked with exposed neon tubes in simplified geometric shapes, which, through their non-referential, inherently spatial, and abstract qualities, surpass categorization. The genesis of Antonakos's panel pieces can be traced back to his installations and wall reliefs of the 1960s. These eventually led to works that combined exposed neon tubes with unstretched, gestural abstract canvases of the 1980s.[2] The early canvas and neon wall pieces were transitional works that incorporated the artist's interest in the transformative qualities of light with painting and drawing and anticipated the mature panel works of the last twenty years.

The Light is part of a larger group of spare neon panels that Antonakos created in the late 1990s. The work is painted stark white, and while its form is inherently geometric, the polygon's shape is broken by fragmentation on the right side. Like all of Antonakos's neon panels, it floats on a wall over a neon light, in this case white light, that emanates from behind. The intrinsic allaying and ethereal qualities in Antonakos's panels have been linked to Greek icons, while his integration of light has been interpreted as halo like. Like all of the artist's works, *The Light* is meant to relate to a specific architectural setting and activates not only the surrounding physical space, but through the incorporation of white neon light, also suggests a psychological space of quietude and self-reflection.[3] In his own words, he is "interested in the possibility of reverberations in the space between the work and the viewer's inner life. For me, the panels relate to a higher consciousness, an open responding sense of self in the here and now, where feeling and thought can come unforced, simply through seeing."[4]

—MNP

1. Irving Sandler, *Antonakos* (New York: Hudson Hills Press, 1999), 58.
2. Stephen Antonakos to author, 5 March 2007. National Academy Museum Archive.
3. Ibid.
4. Stephen Antonakos, "Artist's Notes" in Linda Muehlig, *Stephen Antonakos: Inner Light*, exh. cat. (Northhampton, MA: Smith College Museum of Art, 1997), 23.

RICHARD ANUSZKIEWICZ

(b. 1930)

ANA 1992; NA 1994

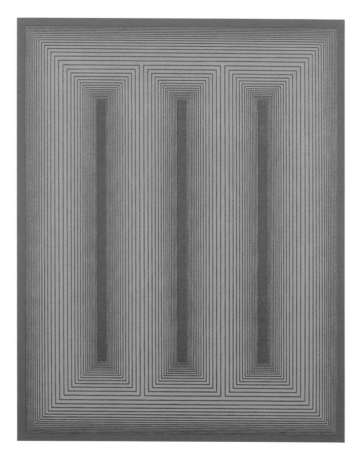

Temple of Deep Crimson, 1985
Acrylic on canvas
60 x 48 inches
NA diploma presentation, 1995
© Richard Anuszkiewicz/Licensed by
VAGA, New York, NY

A pioneer of Optical or Op art, Richard Anuszkiewicz initially worked in a representational style reminiscent of Edward Hopper before being anointed "one of the new wizards of Op," by *Life* magazine in 1964.[1] Anuszkiewicz was born in Erie, PA and in 1948 enrolled at the Cleveland Institute of Art, where he received his BFA in 1953. The year before he graduated, Anuszkiewicz won the Pulitzer Traveling Scholarship from the National Academy of Design. Eschewing travel to Europe, the artist instead chose to attend the School of Art and Architecture at Yale University where he studied under Joseph Albers from 1953 to 1955. At Yale Anuszkiewicz was exposed to the work of Swiss artist Paul Klee and the writings of psychologist James J. Gibson and art historian and psychologist Rudolf Arnheim, both of whom were interested in visual perception—important influences that combined and shaped Anuszkiewicz's abstract work.[2]

In 1960 Anuszkiewicz had his first solo exhibition in New York at The Contemporaries, where the Museum of Modern Art bought two of his works for their collection even though Op art would soon generate controversy for being "too coolly calculated, too scientifically planned, too technical, too spectacular, too intellectual and optically too obtrusive."[3] Early works by Anuszkiewicz were painted freehand and often consist of small geometric shapes painted over a solid color background creating a larger distorted shape that appears to be bulging, contracting, or twisting. These paintings have been interpreted as illustrating visionary architect Buckminster Fuller's notion of *tensegrity* or the balance between the forces of tension and integrity inherent in a physical structure. Throughout the 1960s, Anuszkiewicz's work became increasingly visible through its inclusion in a number of important group exhibitions including 15 Americans (1963), The Responsive Eye (1965), both at the Museum of Modern Art, and Documenta IV in Kassel, Germany (1968).

Temple of Deep Crimson is a quintessential example of Anuszkiewicz's mature style and is from a series of paintings executed by the artist beginning in the early 1980s. Each incorporates a repeating pattern of vertically oriented rectangles surrounded by concentric lines of a startlingly different color. Completed after the artist returned from a trip to Egypt, it contains three central rectangles of saturated crimson surrounded by concentric lines of equally saturated green and orange hues.[4] Symmetry is essential in Anuszkiewicz's work, and by juxtaposing opposite colors of equal saturation in works from the *Temple* series, there is a visual fluctuation between figure and ground, creating a vibrating or pulsating sensation in the eye. The result is a release of energy, or as Karl Lunde notes: "The energy of color is released as two lines of different colors approach one another in measured relationships, and it is this *color energy* that Anuszkiewicz studies."[5]

—MNP

1. Warren R. Young, "Op Art," *Life* 57 (December 28, 1964): 133.
2. Karl Lunde, *Anuszkiewicz* (New York: Harry B. Abrams, 1977), 23.
3. Thomas Buchsteiner and Ingrid Mössinger, eds., *AnuszkiewiczOpArt* (Tübingen: Institut für Kulturaustasch, 1997), 8; Hilton Kramer, "Art: Clashing Values of 2 Generations," *New York Times* 6 November 1965, 26; John Canaday, "Richard Anuszkiewicz: It's Baffling," *New York Times* 5 April 1969, 23; James R. Mellow, "Was Op Art Just a Flop Art?" *New York Times* 7 October 1973, 171.
4. Richard Anuszkiewicz, telephone interview with author, September 27, 2006.
5. Lunde, *Anuszkiewicz*, 37.

WILL BARNET

(b. 1911)

ANA 1974; NA 1982

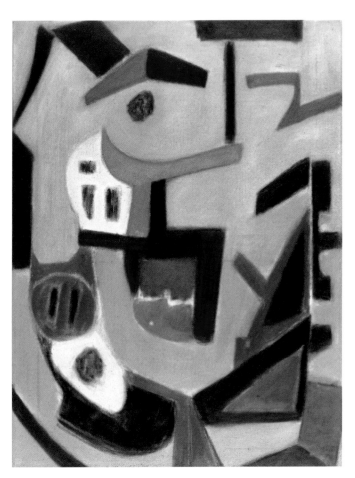

Joyous, 2006
Oil on canvas
32 ½ x 24 ½ inches
Courtesy Babcock Galleries
© Will Barnet/Licensed by VAGA, New
York, NY

Few artists have had as lengthy and productive a career as Will Barnet. His paintings, prints, and drawings combine spiritual aspects with notions of classical structure and have been informed by sources as varied as French Neoclassicism and Peruvian textiles. Barnet was born in Beverly, Massachusetts and as a child enthralled by art, he would travel to Boston to visit the Museum of Fine Arts, art galleries, and bookshops. He eventually enrolled in the School of the Museum of Fine Arts, Boston, where he followed a traditional Beaux-Arts education of anatomy, color theory, art history, and drawing from the cast and from life under Philip L. Hale, ANA. Barnet continued his education at the Art Students League in New York, winning a scholarship in 1931. It was there he learned printmaking and soon became the League's official printer.[1] Barnet's early works are Social Realist depictions of Depression-era hardships.

Throughout the 1940s, however, Barnet moved increasingly toward abstraction and he soon completely eliminated representation from his work. As one of a small group of artists known as the Indian Space painters, whose abstractions were antithetical to concurrent Abstract Expressionism and combined geometric shapes with totemic and pictographic motifs derived from Native American art, Barnet characterized his work as a desire to surpass Cubism and to create an authentic, American modern art.[2] He sought to marry modern art with the classical tradition and was the first abstract artist nominated to the National Academy in 1953, although he was not actually elected until 1974. In 1954 he joined the American Abstract Artists, a group dedicated to the exhibition and perpetuation of abstract art. Barnet wrote extensively on abstraction and contributed an essay to the group's 1959 publication *The World of Abstract Art*.[3] His abstractions became more severely geometric until the transitional years of the early 1960s when representation reappeared in his work. This figurative tendency would continue for more than forty years until the artist's recent return to abstraction in 2003.

Joyous is from Barnet's latest group of paintings that continue abstract ideas the artist was exploring in the 1950s but never fully realized when he shifted to figuration in the 1960s.[4] Throughout his entire career, regardless of working abstractly or figuratively, Barnet has been devoted to creating paintings, prints, and drawings within the framework of classical principles of order, stability, harmony, and grace.[5] While disparate, abstract geometric shapes seem to float on a light-blue ground in *Joyous*, each one can be read within the matrix of a highly ordered composition. These late paintings look back to earlier work by Barnet and they can be seen as a synthesis of abstraction and figuration, suggested here by the cat in the lower left corner and other vaguely corporeal shapes.[6] Celebratory themes of youth have been a subject for the artist for more than sixty years and in *Joyous*. —MNP

1. Robert Doty, *Will Barnet* (New York: Harry N. Abrams, Inc., 1984), 23.
2. Gail Stavitsky, *Will Barnet: A Timeless World*, exh. cat. (Montclair, NJ: The Montclair Art Museum, 2000), 23.
3. Will Barnet, "Aspects of American Abstract Painting," in American Abstract Artists, *The World of Abstract Art* (New York: George Wittenborn, Inc., 1957), 105-114.
4. Gail Stavitsky, *Will Barnet: Recent Work*, exh. cat. (Montclair, NJ: The Montclair Art Museum, 2007), n.p.
5. Ibid.
6. Will Barnet, conversation with author, July 17, 2006.

ELMER BISCHOFF

(1916–1991)

ANA 1973; NA 1985

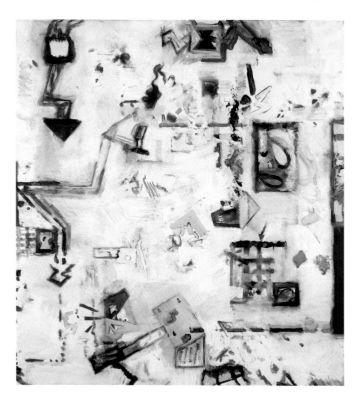

#35, 1978
Acrylic on canvas
85 x 80⅛ inches
NA diploma presentation, 1986

Best known as one of the three Bay Area figurative artists of the 1950s (along with David Park and Richard Diebenkorn, NA), Elmer Bischoff studied in the progressive art department of University of California, Berkeley in the 1930s. Following his service in the Air Force during World War II, Bischoff was appointed as a faculty member at the California School of Fine Arts (renamed in 1961 the San Francisco Art Institute), where he taught until 1952. Under the guidance of the recently appointed director of the school, Douglas MacAgy, the CSFA became a crucible of progressive ideas and experimental work. Other faculty members at the school included Richard Diebenkorn, Claire Falkenstein, David Park, Ad Reinhardt, Mark Rothko, Hassel Smith, and Clyfford Still. It was in this environment that Bischoff participated in developing Abstract Expressionism in San Francisco, becoming one of its most prominent early proponents.

In 1952, however, Bischoff made a decisive break from abstraction, along with Park (who had "defected" in 1950) and later Diebenkorn, who would join the other figurative dissenters in 1955. After an era in which abstraction had become an overwhelmingly pervasive force, figuration offered a new set of challenges. For Bischoff, this shift toward representation and the figure was purely a personal decision of "keeping alive in the studio."[1] By the late 1950s Bischoff and his fellow representational painters had begun to receive national attention, and many artists and critics saw them as a viable alternative to Abstract Expressionism. This critical momentum carried Bischoff through the 1960s and into the summer of 1972, when he produced several small experimental abstract canvases over the course of a few months.[2] He would eventually renounce figurative work for good in 1974, and began to number, instead of title, his canvases.

Bischoff's *#35* belongs to this group of numbered series done during the 1970s. At this time the artist also switched from painting in oil to painting in acrylics and incorporating other media such as chalk and charcoal. In many ways, the late abstractions are a return to some of the methods and concepts that Bischoff had employed in the 1940s and 1950s. The spirited feeling imbued in *#35* is underscored by the bright colors on a white ground and seemingly improvisational configurations of shapes. Bischoff's late paintings are stylistically reminiscent of Wassily Kandinsky's "improvisations"—colorful abstractions from the first decade of the twentieth century. They also reflect the artist's interest in astrophysical studies and Jewish mysticism of the Kabbalah. While Bischoff was committed to painting intuitively and these works were not necessarily meant to illustrate a specific concept, they were informed by the kabbalistic notion that creation began with a cataclysmic blast sending particles ever-expanding outward.[3] He described the works from this period as "happy disasters."[4] —MNP

1. Susan Landauer, *Elmer Bischoff: The Ethics of Paint* (Berkeley: University of California Press, 2001), 61.
2. Ibid., 138.
3. Ibid., 145.
4. Ibid., 152.

ROBERT BLACKBURN

(1920–2003)

ANA 1981; NA 1994

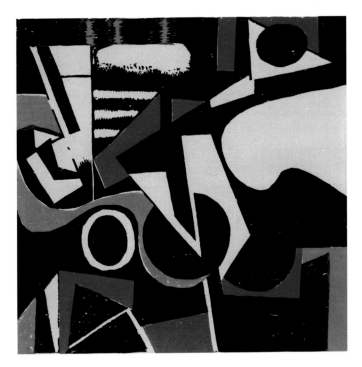

Modern Times, 1984
Color woodcut on white Japanese paper
EDITION: Unknown
IMAGE SIZE: 11¼ x 11⁵⁄₁₆ inches
SHEET SIZE: 21¹⁵⁄₁₆ x 16 inches
ANA diploma presentation, 1998

Robert Blackburn was born in Summit, New Jersey and spent his formative years in Harlem. At age thirteen, he participated in Charles Alston's Harlem Arts Workshop and while still in high school took art classes, including lithography, at the WPA-sponsored Harlem Community Art Center. He attended the Art Students League from 1940 to 1943, studying with Will Barnet, NA, with whom he would forge a lifelong friendship. He later collaborated with Barnet in the creation of color lithographs from as many as fifteen stones, a highly complex and innovative approach for American printmaking in the early 1950s. From 1957 to 1963 Blackburn worked at Universal Limited Art Editions (ULAE) in Long Island, as their first master printer. His work there printing for Helen Frankenthaler, NA, Grace Hartigan, Jasper Johns, NA, and Robert Rauschenberg, NA, contributed to the graphics boom of the early 1960s.

Blackburn's most important achievement was founding and overseeing the cooperative Printmaking Workshop in New York. Founded in 1948, the Workshop provided artists a congenial atmosphere in which to create lithographs (later offering facilities for other printmaking techniques), an environment much more conducive to experimentation than commercial printing workshops. Renamed the Robert Blackburn Printmaking Workshop in 2002, it continues its founding mission of "fostering an artistic community of racial, ethnic and cultural diversity for the making of fine prints within an environment responsive to exploration, innovation and collaboration; and to promoting the global appreciation and understanding of the fine art print."[1]

Deborah Cullen, who worked with Blackburn at the Printmaking Workshop, has written of his working process and his conception of imagery in a horizontal orientation, a flatbed approach to which printmaking lends itself.[2] While he is better known for his lithographs, Blackburn created a handful of woodcuts and in more than one instance he reassembled the blocks used in one print to create new prints. As his goal was expression and experimentation, he often failed to document how many impressions of each work were printed, leaving the edition unknown. *Modern Times* combines a collage aesthetic with the Cubist influence manifest in Blackburn's previous works. Close observation reveals that the yellow-green was printed first, followed by red, then black, then blue. The shapes are balanced so that the lighter areas read as positive rather than negative space, and incomplete coverage of the ink in all areas adds texture to the otherwise flat shapes. A version of this woodcut was first printed in 1975, created from blocks initially made for *Block on Blue* (1974; Library of Congress, Washington, DC). Blackburn reprinted *Modern Times* in 1984, at which time he added the yellow-green background color; and again in 1996, when he rotated the image ninety degrees clockwise, and titled it *Urban Renewal* (Library of Congress, Washington, DC).[3]

—CMB

1. The Elizabeth Foundation for the Arts, Robert Blackburn Printmaking Workshop website, http://efa1.org/RBPW/?Page=RBPW-Home, accessed January 8, 2007.
2. Deborah Cullen, "Robert Blackburn (1920–2003): A Printmaker's Printmaker," *American Art* 17 (Autumn 2003): 94.
3. Deborah T. Cullen, "Robert Blackburn: American Printmaker" (PhD diss., Graduate School and University Center of the City University of New York, 2002), Appendix 1.

JAMES BOHARY

(b. 1940)

ANA 1992; NA 1994

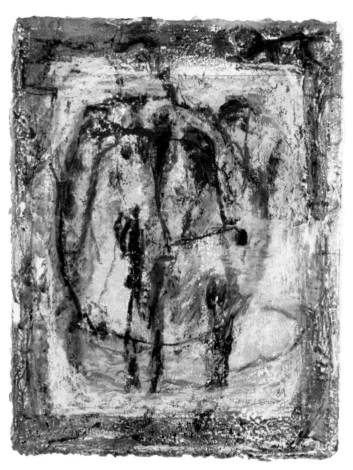

Dinner Plate, 1989
Retouched monotype with acrylic and oil
 pastel on paper
21 1/4 x 16 1/2 inches
Gift of the artist, 2004
© 1989 James Bohary

While James Bohary does not necessarily consider himself an abstract artist in the strict sense of the word, his work is part of the lineage of abstract painting of the last fifty years. Many of his paintings suggest an "overall" effect and recall Harold Rosenberg's dictum that, for a painter, the canvas was an arena in which to act, rather than a space in which to reproduce an object.[1] Bohary initially studied graphic design at the School of Visual Arts in the early 1960s before receiving a BS in Art Education at New York University. He then studied with Philip Guston, ANA elect, at the New York Studio School and emerged as an abstract painter on the eve of a period when painting was often referred to as all but dead. His work has been linked to the action paintings of Franz Kline and Willem de Kooning, NA elect, and for more than thirty years Bohary has explored the universality of abstract painting through process and gesture. His awareness of the efficacy of abstraction is reflected in a recent statement: "I consider myself fortunate to be involved with a dialogue that has the ability to be understood by all people, regardless of the manner in which they write or speak."[2]

Bohary has been referred to as a third- and even fourth-generation Abstract Expressionist and he has consistently tapped into both the conscious and unconscious mind to arrive "at a place in his painting where both intellect and emotion can co-exist."[3] The artist is interested in mark making, and it is through the successful reconciliation of these various components that he is able to achieve a transcendent abstract vocabulary. Not all of the artist's paintings are completely abstract, however, and in many there are references to natural elements. Bohary first exhibited in the National Academy's Annual in 1993, and in the Annual of 1996 he won the Edwin Palmer Memorial Prize for the best marine painting. Since 1998 he has been a professor at the State University of New York, Binghamton and has been one of the more prolific abstract artists to exhibit at the National Academy.

While *Dinner Plate* lacks the physical impasto of some of Bohary's oil paintings, the artist has maintained his hallmark of tactility by layering the gestures and juxtaposing pinks, blues, browns, and black within a frame of earth tones to create a visual sense of impasto. Like many of Bohary's works, *Dinner Plate* evolved over a long period of time and actually began as one from a series of studio monotypes that he created in New York after his return from Barcelona, Spain in 1989. It was then reworked by the artist with acrylic and pastel.[4] *Dinner Plate* is suggestive of representation not only in title, but also by the circular delineation of the central image. This referential quality combined with the light palette of pinks and blues and the serrated line repeated throughout the composition suggest some of the qualities of concurrent Neo-Expressionism of the 1980s. —MNP

1. Harold Rosenberg, "The American Action Painters," *Art News* 51 (December 1952): 22.
2. James Bohary, "Artist's Statement," in Rose C. S. Slivka, *The Paintings of James Bohary*, exh. cat. (Hanover, NH: Jaffe-Friede and Strauss Galleries, Dartmouth College, 1998), 3.
3. Sue Scott, "James Bohary: Finding Images in Abstract Fields," *Cover* 12 (1998): 9.
4. James Bohary correspondence with Isabelle Dervaux, 24 April 2004, National Academy Museum Archive.

JAMES BROOKS

(1906–1992)

ANA 1980; NA Elect 1985

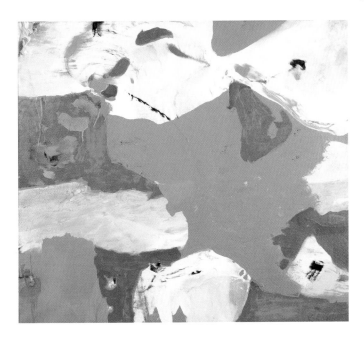

Kardom, 1981
Acrylic on canvas
32 x 36 inches
ANA diploma presentation, 1984
Art © Estate of James Brooks/Licensed by
 VAGA, New York, NY

Originally from St. Louis, Missouri, James Brooks undertook his earliest artistic training at the Southern Methodist University in Dallas. In the summer of 1926, he moved to New York City, where he worked as a commercial illustrator while attending night classes at Grand Central School of Art and later the Art Students League. In the 1930s Brooks explored the rhythmic strokes of the Social Realist style, executing a series of murals commissioned by the WPA's Federal Art Project. His most famous mural, *Flight*, was completed in 1942 and installed in the Marine Air Terminal in New York's LaGuardia Airport. These federal commissions brought him into contact with artists such as Jackson Pollock and Philip Guston, ANA elect. In March 1942, however, Brooks enlisted in the army, serving two and a half years initially as a Civil Pilot Engineer stationed at Mitchel Air Force Base, Long Island, and soon thereafter as a combat artist stationed near Cairo, Egypt.[1]

In the summer of 1945 he returned to New York. Anxious to restart his artistic career, Brooks focused exclusively on painting, eschewing all commercial assignments that would have encroached on his time. He revived his connections to the art scene and even moved into Jackson Pollock's old New York City apartment. The late 1940s was an invigorating period of radical experimentation and innovation; Brooks's unprecedented use of the staining technique during this time has even led some to question whether it was Brooks or Helen Frankenthaler who truly pioneered the groundbreaking procedure.[2] Speaking of this decade, Brooks declared that "it was about time for Freud's seeds to really ripen."[3] By 1949, Brooks's art was conceptually and aesthetically in line with New York's avant-garde, abstract scene. His luminous expanses of unmodulated color and pure expression evoked a spectrum of colors. Although often overshadowed by his fellow Abstract Expressionists, Brooks's ability to harmonize the strata of spectral dissonance within multilayered compositions of hatched strokes and chiseled lines was not overlooked by the Whitney Museum of American Art, which venerated Brooks with a retrospective exhibition in 1963.

Kardom is rooted in Brooks's 1960s exploration of acrylics and exhibits a grace and clarity that had matured after decades of artistic development. The composition presents an elegantly orchestrated arrangement of forms, punctuated by slabs of pure, clearly defined color that highlight the process and materiality of paint. *Kardom*'s broad areas of limited color range interspersed with gestural drips and brushstrokes harmonizes the disparate elements of tranquility and dissonance to present an infinitely expansive composition. Wishing for his work to speak for itself rather than be mediated by textual explanation, Brooks remained virtually silent in the face of questions of meaning and interpretation. He has, however, offered insights into his process: "My painting starts with a complication on the canvas surface, done with as much spontaneity and as little memory as possible. This then exists as the subject... At some undetermined point the subject becomes the object, existing independently as a painting."[4] —MS

1. James Brooks, interview with Dorothy Seckler, 10 and 12 June 1965, online transcript, Archives of American Art, Smithsonian Institution.
2. Stephen Maine, "James Brooks at Artemis Greenberg Van Doren," *Art in America* 92, no. 4 (April 2004): 128.
3. Brooks interview with Seckler.
4. James Brooks, "Statement," in *Contemporary American Painting* exh. cat. (Urbana: University of Illinois Press, 1952), 174.

BERNARD BRUSSEL-SMITH

(1914–1989)

ANA 1952; NA 1972

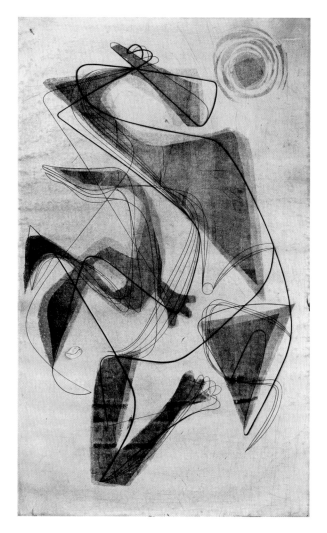

Cain and Abel, ca. 1957
Engraving and soft ground etching on
 cream wove paper
EDITION: Artist's proof
IMAGE SIZE: 19 5/16 x 11 7/8 inches
SHEET SIZE: 24 5/8 x 17 3/16 inches
NA diploma presentation, 1973
© Peter Brussel-Smith

A native New Yorker and known primarily for his figurative prints and illustrations, Brussel-Smith studied at the Pennsylvania Academy of the Fine Arts and the New School for Social Research in New York, where he learned wood engraving from Fritz Eichenberg. In 1935 he traveled to Europe on a Cresson Traveling Scholarship. Brussel-Smith worked extensively in commercial illustration and taught printmaking at The Cooper Union for the Advancement of Science and Art, the Brooklyn Museum Art School, Philadelphia College of Art, City College of New York, and the National Academy of Design (1966–67 and from 1972–73).

Brussel-Smith worked almost exclusively in the graphic arts and was exceptionally gifted as a wood engraver. His fondness for printmaking is evident in the statement: "The graphic artist . . . has an affinity for materials which to him are alive. He watches a piece of boxwood breathe and pulsate under his graver, he feels the molecular flow of copper as though it were a self-contained body of water being displaced under the thrust of his burin."[1] Uncharacteristically abstract for Brussel-Smith, this image of Cain and Abel was undoubtedly created while the artist was working in Atelier 17, Stanley William Hayter's printmaking workshop in Paris. Renowned for its technical innovations, Atelier 17 was Brussel-Smith's chosen venue in which to develop a new method of relief etching for use in his commercial illustration work. The artist wrote in December 1959 of his success in finding a printmaking technique that would enable greater tonal effects while remaining compatible with letterpress printing, something not available through wood engraving or traditional etching.[2] During his six-month stay at Atelier 17 he helped to develop of a new kind of acid-resist process that is used to draw the design on the metal plate. This allows the artist to print the image in relief while simultaneously creating tonal gradations.

Although *Cain and Abel* is not a relief etching, it does utilize the technique of textured patterns pressed into softground, a technique that he would incorporate into his relief etchings, and one that he most likely learned at Atelier 17. Another technique commonly used at that workshop was *gauffrage*, here visible in the small area of white relief at lower left. It is achieved by gouging into the plate an area that is too wide to hold ink when the surface is wiped off prior to printing. The overall aesthetic of the print is also directly related to the influence of Hayter and his studio: expressive, curving lines drawn with the burin, indicating movement as well as form. The composition of *Cain and Abel* requires focused viewing to be discerned, but is in keeping with earlier images such as Albrecht Dürer's *Cain Slaying Abel* of 1511, a woodcut Brussel-Smith no doubt would have known. Here, however, the combination of Surrealist-inspired imagery and iconic subject matter also calls to mind Adolph Gottlieb and Mark Rothko's important statement defending their use of abstraction as a universal language to represent mythological, archaic, and otherwise "timeless" subject matter.[3] These artists' statements reflected an aesthetic turning point for the painters of the New York School in the mid-1940s. —CMB

1. Bernard Brussel-Smith, "Relief Etching: A Newly Revised & Improved Graphic Art," *American Artist* (December 1959): 23.
2. Ibid, 24.
3. As cited in Edward Alden Jewell, "'Globalism' Pops into View," *New York Times* 13 June 1943, 9.

NICOLAS CARONE

(b. 1917)

NA 2001

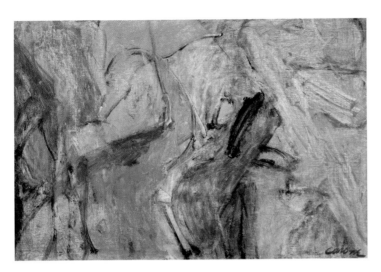

Summer Tryst, 1985
Oil on wood panel
20 x 30 1/8 inches
NA diploma presentation, 2004

Nicolas Carone first studied art as a child of eleven years old when he began commuting from Hoboken, New Jersey to New York City to attend classes at the Leonardo da Vinci Art School.[1] In 1933, Carone enrolled in drawing classes at the National Academy of Design and quickly advanced through the traditional curriculum of working from the figure under the tutelage of Social Realist painter, Leon Kroll, NA, who became his mentor. It was the German émigré painter, Hans Hofmann, however, who would have the greatest influence on Carone and his work. In 1941, Carone enlisted in the Air Force and was stationed at Mitchel Air Force Base, Long Island, but would spend his spare time attending Hofmann's classes in New York City. Hofmann insisted on working from nature and made no distinction between abstraction and representation, leading many of his students to become figurative artists. Carone, however, began working abstractly, but always drew inspiration from nature. He recalled: "We always worked from nature. No matter how abstracted the drawing became, it came from nature. And I believe in that, by the way."[2]

Carone had won the Prix de Rome in 1941, but was unable to go because of the war. In 1947 he used the money from the award to spend a few years in Italy, where he met Afro Basaldella, Alberto Burri, and Roberto Matta, who would become a close friend and influence his work greatly.[3] Carone returned to the U.S. after three and a half years and participated in the Ninth Street show in 1951, seminal for its showcasing of Abstract Expressionism. Within two years Carone was hired to run the newly established Stable Gallery where he showed many Abstract Expressionist artists, such as Ernest Briggs, Edward Dugmore, NA, John Ferren, Robert Rauschenberg, NA, Cy Twombly, NA elect, and Conrad Marca-Relli. Carone has held numerous teaching positions throughout his career and was a founding faculty member of the New York Studio School, where he taught for more than twenty years. Since the end of the 1960s he has been returning annually to Italy, where, in the mid-1980s, he founded the International School of Art in Umbria.

Carone synthesizes various techniques and modes of execution in much of his work of the last sixty years and he has tread a fine line between abstraction and representation, as evidenced in Summer Tryst. The artist has combined the figure drawing he learned at the National Academy of Design and the abstracting influence of Hans Hofmann with the automatism of Matta and the Surrealists to create works that defy strict classification.[4] While Carone continues to work from nature, the limited palette and the gestural application of paint in Summer Tryst strongly recall the work of artists of the New York School. Hofmann's legacy lives on in works such as this that navigate successfully between abstraction and representation. Indeed, Summer Tryst has corporeal references that elicit Willem de Kooning's statement that "Even abstract shapes must have a likeness."[5] —MNP

1. Nicolas Carone, interview with Paul Cummings, 11–17 May 1968, online transcript, Archives of American Art, Smithsonian Institution.
2. Ibid.
3. David Ramm, "Nicolas Carone, Artist," Current Biography 67 (July 2006): 19.
4. For years Carone has produced painted portrait heads and highly-realized figure drawings. See Isabelle Dervaux, Nicolas Carone: A Selection of Works on Paper, exh. cat. (New York: Lohin Geduld Gallery, 2005).
5. As cited in Thomas B. Hess, Willem de Kooning (New York: The Museum of Modern Art, 1968), 47.

EDMOND CASARELLA

(1920–1996)

ANA 1993; NA 1994

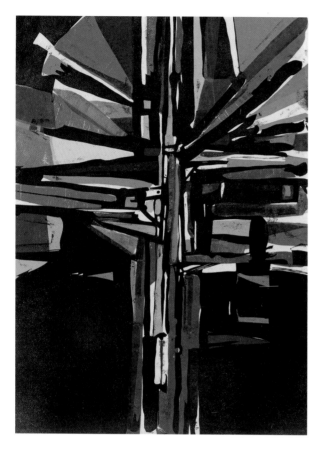

Tree Burst, 1958
Color paper relief print on beige laid paper
EDITION: 14/18
IMAGE SIZE: 30 1/16 × 21 7/8 inches
SHEET SIZE: 31 × 22 9/16 inches
NA diploma presentation, 1994
© Mary Casarella

Edmond Casarella was a pioneer printmaker and one of a group of artists who refined and perfected the paper relief cut technique in the late 1940s and early 1950s. It was a period of intense experimentation, about which his good friend and fellow printmaker Vincent Longo, NA, has said, "We were all looking at ways to extend [the process of] the relief print."[1] Casarella was born in New Jersey in 1920 and as a young man attended The Cooper Union for the Advancement of Science and Art studying under Raymond Dowden and Peppino Mangravite, NA. After graduation Casarella worked with Anthony Velonis, who had been the head of the WPA's Federal Art Project silkscreen printing division. Like many artists of his generation, Casarella served in the army, enlisting in 1944; he saw combat action as part of an antitank unit in the Battle of the Bulge.

Following the war, Casarella continued his studies at the Brooklyn Museum Art School where he learned printmaking under Gabor Peterdi, NA. By the late 1940s Casarella and Longo began to develop the paper relief print process using cardboard.[2] This technique, also known as the collagraph, is created by adding layers of paper to a support in order to create the printing surface. As David Acton has noted, the additive process of making the relief print blocks came naturally to Casarella as he was also a talented sculptor.[3] During the 1950s, the relief print process emerged as a viable way for printmakers to express their ideas and by the end of the decade was seen as an acceptable alternative to the more laborious technique of woodcut printing.[4] This process would dominate Casarella's work of the 1950s and '60s, and then again in the 1980s.[5]

One of the attractions of paper relief prints was its versatility. Bernard Chaet, NA, used Casarella's *Tree Burst* as a prime example of the medium in a 1958 article for *Arts* in which he identifies a narrowing gap between painting and printmaking, attributing it to the rise in prints of an unlimited color range.[6] While *Tree Burst* is a quintessential example of relief printing, it is also an archetypal Abstract Expressionist print. The composition emanates from a central, vertical element that recalls a faceted, tree-like shape. While the lower portion of the print is essentially solid dark tones, its upper portion is filled with forms radiating outward from its center. Casarella used groupings of geometric elements to create this effect, but he did so in an extremely gestural way, effectively giving this "tree" its "burst." Despite the overall green and brown tonality of the print, it was a complex technical undertaking, created with six separate blocks and twenty different ink colors.[7] The artist would initially create a study for the work and then print each of the separations before embarking on the final version. *Tree Burst* is a wonderful example of how the influence of Abstract Expressionism reached beyond the medium of painting and permeated nearly every aspect of the arts in the 1950s.

—MNP

1. Vincent Longo, telephone interview with author, October 6, 2006.
2. *Edmond Casarella*, exh. cat. (New York: Susan Teller Gallery, 2004), n.p. Additional early proponents of the paper relief print were John Ross, NA and Clare Romano, NA.
3. David Acton, *The Stamp of Impulse: Abstract Expressionist Prints* (Worcester: Worcester Art Museum, 2001), 154.
4. James Watrous, *A Century of American Printmaking, 1880–1980* (Madison, WI: The University of Wisconsin Press, 1984), 188.
5. *Edmond Casarella*. n.p.
6. Bernard Chaet, "Studio Talk," *Arts* 33 (November 1958): 66.
7. Ibid.

WILLIAM CROVELLO

(b. 1929)

NA 2002

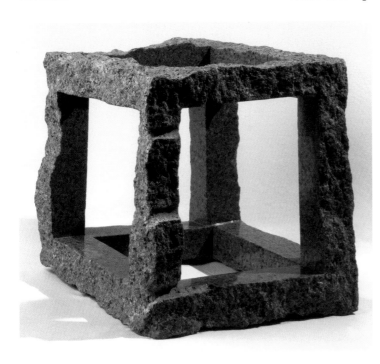

Granite Drawing (OK Bonito), 1985
Red granite
16 x 16 x 15 1/2 inches
NA diploma presentation, gift of Brigitte
and William Crovello, 2003

Best known for his large public sculpture, New York City native William Crovello initially studied painting at the Rhode Island School of Design from 1947 to 1951. He entered the air force in 1952 and was stationed in Japan from 1954 to 1955. Following his military duty, Crovello, seeking his expressive muse, returned to Japan in 1957 for four years and became enchanted with the rich tradition of classical calligraphy. The artist absorbed both the deep philosophy and technical execution of the ancient script by immersing himself in calligraphic study. After returning to New York in 1961, the artist moved to Spain in 1968 and shifted from painting to sculpture, creating forms whose presence activated three-dimensional space. His stone and metal works draw directly from the smooth strokes of the Japanese brush, echoing the graceful brevity and elegant fluidity of an ancient tradition. Following the movement of the calligraphic stroke, Crovello created numerous public sculptures, such as the painted steel *Cubed Curve* installed in 1972 outside the Time-Life Building in New York City, and the Swedish granite *Katana* (1980) in the Donald M. Kendall Sculpture Gardens at PepsiCo, Purchase, New York.

Since 1977 nearly all of Crovello's stone pieces have been fashioned in the artist's studio in Pietrasanta, Italy.[1] Thus, Crovello incorporated a second cultural tradition into his work and merged Eastern philosophy with a Western sensibility. As a result, his sculpture acquired an archetypal dichotomy; Crovello has described his works as embodying "the Italian instinct to change stone, to polish it, shape it . . . and the Japanese love of natural, unworked stone."[2] Expanding on the lyrical harmony within his minimalist forms, Crovello has accented the play between open and closed spaces by silhouetting form against empty space, while his sculptures have been noted for their combination of spontaneous and premeditated impulses.[3]

Crovello's intimately scaled *Granite Drawing (OK Bonito)*, carved in Italy in 1985, embodies the dichotomy of expressive minimalism that has characterized his work for more than a quarter of a century. The piece captures the Japanese love of naturalism and precise calligraphic line, imprinting upon the work the real physicality of rough stone infused with the weight of Eastern tradition. Yet the formal treatment of *Granite Drawing* echoes the Italian desire to manipulate nature and to embrace the malleability of the material world. Crovello's formal confidence enabled him to fuse these opposing sculptural techniques and present a synchronization that accords naturalism with manipulation. Elaborating on this treaty of opposites, the artist asserted that, "if there were such a thing as a visual dictionary *Granite Drawing* would be a concise, abbreviated demonstration of the contrasting Italian and Japanese stone aesthetic."[4] Thus, within the stalwart frame of a hollowed stone cube, Crovello harmonized expressive, artistic freedom with classical, disciplined restraint. —MS

1. William Crovello, email correspondence with Marshall Price, 31 January 2007. National Academy Museum Archive.
2. Ibid.
3. Massimo Duranti and Bruno Mantura, *William Crovello: Tokyo/Tuscany* (Florence: Sala d'Arme di Palazzo Vecchio, 2002), n.p.
4. Crovello, email correspondence with Price.

EDWARD DUGMORE

(1915–1996)

ANA 1992; NA 1994

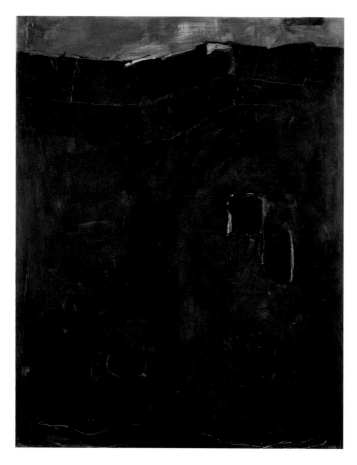

Opus 130-B, 1987
Oil on canvas
48 × 38 inches
ANA diploma presentation, 1993

Edward Dugmore was born in Connecticut and first studied at the Hartford Art School in the late 1930s, where he not only learned old master techniques of painting but also studied works from the northern and southern Renaissance.[1] After receiving his bachelor's degree, Dugmore served in the Marine Corps during World War II. Following the war, Dugmore moved to San Francisco in 1948, where for two years he attended the California School of Fine Arts under the GI Bill and fell under the tremendous influence of Clyfford Still. In 1949 Dugmore was a founding member of the Metart Gallery, San Francisco's first cooperative gallery and an early venue for abstraction in that city. The name of the gallery was a conflation of the words *metaphysical* and *art* and in Dugmore's own words, it was intended to "break up this idea that we were all a gang of nonobjective painters."[2] After two years at the CSFA Dugmore moved to Mexico, where he stayed briefly before moving to New York.

In February 1953 Dugmore had his first solo exhibition in New York at the Stable Gallery. Along with that of fellow abstractionist Ernest Briggs, Dugmore's work showed similarities to Still's by incorporating large areas of dark color, often creating an abstract, chasm-like effect. This characteristic led Hans Hofmann to dub these two artists "Stillites," a pejorative term that was adopted by members of the New York School.[3] During the 1950s and 1960s, however, Dugmore showed frequently in New York to some acclaim. Dore Ashton, one of the leading critics, praised the artist's paintings for their, "huge flat forms that seem to spread infinitely into space."[4]

Like many of the artist's works, the enigmatic qualities of *Opus 130-B* suggest more than a mere grappling with formal issues of the materials or the process of painting but rather an attempt to come to terms with emotional experiences that transcend the physical world. Dugmore was an enormous fan of Beethoven's music, and this painting is from a series of works he created based on the composer's quartets, hence its title.[5] Like many of the artist's canvases, *Opus 130-B* utilizes an overarching dark palette of blacks and grays in an attempt to evoke the feeling in Beethoven's work. Dugmore's approach to painting was synesthetic and he considered the painter a "philosopher with a brush," as revealed in an early artist statement: "If I say that I am not just *making* paintings, I would not be making myself clear. Of far greater significance and permanent value than what happens on the surface of the paintings are the ideas they are made of and the feelings they evoke when *you* look at them."[6] —MNP

1. Dore Ashton, "About Art and Artists," *New York Times* 20 October 1956, 17.
2. Susan Landauer, *The San Francisco School of Abstract Expressionism* (Berkeley: University of California, 1996), 85. The gallery lasted less than two years and the original artists were Jeremy Anderson, Ernest Briggs, W. Cohantz, Hubert Crehan, Edward Dugmore, NA, Jorge Goya, William Huberich, Jack Jefferson, Kio Kiozumi, Zoe Longfield, Frann Spencer, and Horst Trave.
3. Ibid., 127.
4. Dore Ashton, "Art: A Dugmore Show," *New York Times* 29 April 1960, 24.
5. Edward Dugmore, interview with Tram Combs, 13 May 1993, online transcript, Archives of American Art, Smithsonian Institution. The full title of the musical composition by Beethoven is String Quartet no. 13 in B flat major, Opus 130.
6. Dore Ashton, *Edward Dugmore, Burning Bright: Paintings 1950–1959*, exh. cat. (Los Angeles, CA: Manny Silverman Gallery, 1991), 7.

NICK EDMONDS

(b. 1937)

ANA 1992; NA 1994

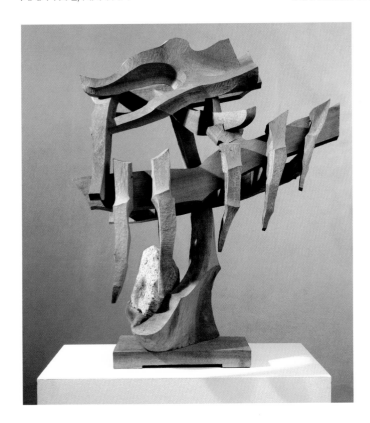

Icicles, 1982
Walnut wood and fieldstone
36 x 30 x 18 inches
ANA diploma presentation, 1993
© 1982 Nick Edmonds

Since the early 1960s sculptor Nick Edmonds has explored the expressive possibilities of carving and constructing with wood. Born in Boston, Edmonds initially studied at the Ogunquit School of Painting and Sculpture before enrolling in the School of the Museum of Fine Arts, Boston, where he studied with Ernest Morenon and Robert Laurent and graduated with honors in 1961. In 1965, Edmonds was hired as professor of sculpture at Boston University, where he would teach for nearly forty years. Many of the artist's works from the mid-1960s were carved from single logs that he found at the town dump in Sharon, Massachusetts. While essentially abstract, these sculptures strongly recall standing and reclining figures and were carved by repeatedly gouging the surface of the wood to create a scalloped effect.[1] In seeking greater expressive possibilities, he began to combine large pieces of wood but found traditional adhesives inadequate for the size and density of the materials. Determined to find a solution, Edmonds sought out cultures that utilized architectural joinery and in 1969 won a travel grant from the Boston Museum School to go to Norway where he could learn about joinery construction.[2]

Edmonds's Norwegian sojourn was not as illuminating as he had hoped so he next turned his attention to traditional Japanese architectural construction. In 1975 he was awarded a Fulbright grant to travel to Kyoto, Japan, where he found both technical and creative inspiration in abundance. For eight months Edmonds observed and painstakingly documented the dismantling and re-assembling of a 600 year-old wooden gate of the Tofukuji Temple.[3] His fascination with specific architectural features, such as where wood meets stone, and his interaction with Japanese rock gardens would have a lasting effect on his sculpture that continues today. He has been able to utilize elements of Japanese carpentry to create his own visual language of expressive shapes and negative space.[4] Upon his return from Japan he began a series of works that incorporated his recently acquired knowledge of joinery with an Eastern-inspired aesthetic. By the late 1980s the artist began to apply polychrome to his work and recently has returned to a more literal figurative style.

Icicles was created as part of this Japanese-inspired group and actually began as a demonstration for a class of students to show how to carve various conical shapes and to illustrate the structural aspects of the wood grain.[5] Edmonds initially carved the icicles in relief, but as he continued to work on the piece they became realized in the round. While it remained inherently referential through the dagger like icicles, the overall effect became more and more abstract. The artist's preceding works had been landscape-based, and while *Icicles* may be a slight departure, it retains a landscape connection through the large rock in the lower portion of the sculpture.[6] Not only does this element suggest a traditional Japanese rock garden, but it also serves a practical function as a counterweight to the heavy walnut wood. —MNP

1. Katherine French, *Nick Edmonds: A Natural World, 1972–2002* (Boston: College of Fine Arts, Boston University, 2002), 9.
2. Ibid., 10.
3. Daniel Dubois and Nick Edmonds, *Nick Edmonds: Sculpture and Drawing* (New Britain, CT: The New Britain Museum of American Art, 1984), n.p.
4. Robert Taylor, "Nick Edomonds sculpture exhibit juxtaposes lively characteristics," *The Boston Daily Globe* December 4, 1988. p. A3.
5. Nick Edmonds, telephone conversation with author, 23 March 2007.
6. Ibid.

LIN EMERY

(b. 1928)

NA 1999

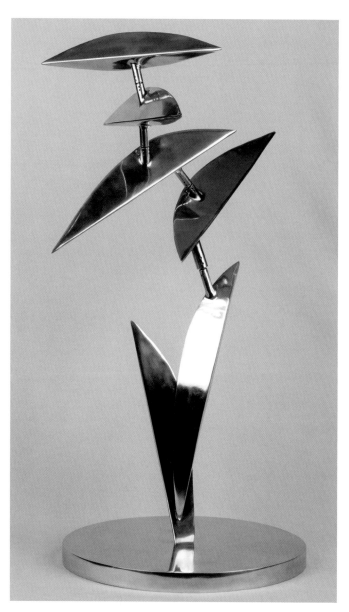

MITRE, 2001
Aluminum and stainless steel bearings
26 x 16 x 16 inches
NA diploma presentation, 2003
Art © Lin Emery/Licensed by VAGA, New
York, NY

Lin Emery never intended to be a sculptor. Born in New York City, she had always shown artistic talent, but as a young woman she moved to Chicago where she worked as a journalist for the *Chicago Sun*. She soon made her way to Paris, however, and translated articles into English for the paper *France Dimanche*. Emery happened to be living across the street from the studio of Ossip Zadkine and was intrigued by its workings. After wandering one day in to Zadkine's studio, out of curiosity, Emery recalled, "he took me on as an example for the students, to show them how you would handle someone who had never done any sculpture."[1] It was under Zadkine's watchful eye that Emery learned figurative modeling, and her early work shows a particular interest in the elongated forms of Romanesque sculpture. After one year in the sculptor's studio she returned to the U. S. and settled in New Orleans.

Soon after her return, Emery learned how to weld in order to create the armatures for large figures. Her interest, however, was diverted from the figures and toward the abstract forms of the armatures themselves. By 1957 she had created her first kinetic sculpture, powered by water and inspired simply by observing the movement of a spoon on the edge of a cup in her kitchen.[2] The artist soon developed alternative techniques for movement, and her works of the 1960s and 1970s achieved this by the use of magnets. In the late 1970s, Emery eschewed the cast and welded bronze that had been her primary material and began to use polished aluminum almost exclusively. In addition to her numerous public commissions, Emery has also played an important role in the fairly small art community of New Orleans as co-founder, along with six other artists, of the city's first cooperative gallery, the Orleans Gallery.

While much of her late work is strongly geometric and has been linked to Constructivism, and the work of other kinetic sculptors, Alexander Calder and George Rickey, NA elect, it is firmly rooted in Emery's own observations of nature and her interest in movement and dance. Emery has said: "The quality of movement is of prime importance; it must be organic and not mechanical. I can evoke a gesture, or a pantomime, or a rhythmic pattern of nature … I juggle and juxtapose to achieve the movement I want; often I am surprised as the finished work invents an added dance of its own."[3] Indeed, while aided mechanistically, the movement of *MITRE* is completely organic. In the 1980s Emery developed a type of ball bearing that allows the various parts of the sculpture to travel on different planes while rotating 360 degrees. *MITRE* was completed for the MITRE Corporation and in Edward Albee's words, "combines the most planned with the most random, resulting in a delighting spontaneity possible only through a combination of precise control of method and a calculation of the unpredictable."[4] —MNP

1. Edward Lucie-Smith, *Lin Emery: Borrowing the Forces of Nature*, exh. cat. (New Orleans: New Orleans Museum of Art, 1996), 8.
2. Ibid., 11.
3. E. John Bullard, "The Kinetic Sculpture of Lin Emery," in *Lin Emery*, exh. cat. (New York: Max Hutchinson Gallery, 1982). n.p.
4. Edward Albee, *Lin Emery*, exh. cat. (New York: Kouros Gallery, 1989), 5.

LAWRENCE FANE

(b. 1933)

NA 2002

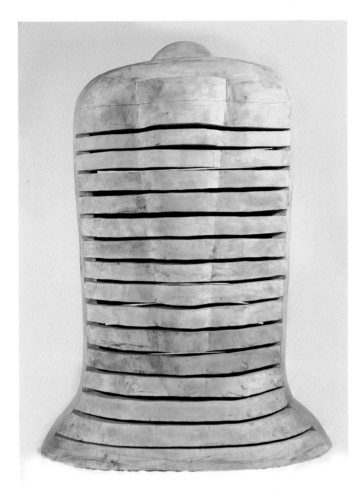

Monument, 1996
Poplar wood
68 x 50 x 24 inches
NA diploma presentation, 2003

Born in Kansas City, Lawrence Fane showed artistic promise at a young age and was encouraged by his family. Intending to become a doctor, however, he enrolled in a premedical program at Harvard University, where during his senior year he took a drawing and sculpture course with George Demetrios that would alter his life. Following graduation, Fane initially enrolled in medical school but after only a few days decided instead to pursue his true calling and entered the School of the Museum of Fine Arts, Boston. There he worked under Demetrios, who would soon become a mentor, and followed a traditional art curriculum of drawing and sculpting from the figure. In 1960, the young artist won the prestigious Rome Prize, allowing him to study at the American Academy in Rome for three years. Living in Italy expanded Fane's visual literacy tremendously and it stimulated a period of rapid maturation in his work.

Upon his return to the U.S. Fane began teaching at the Rhode Island School of Design. In 1966, he joined the faculty at Queens College, where he would remain for more than thirty years. By the 1970s Fane's work had taken a decided turn toward abstraction, and his earlier practice of combining steel and concrete diminished as he began to work almost exclusively with welded steel.[1] In the early 1990s Fane encountered the drawings of engineer and artist Mariano Taccola (1382–ca. 1453), and in 1993 he spent ten months in Los Angeles studying facsimiles of Taccola's notebooks, which inspired him to write a scholarly article on the inventive and unique qualities in Taccola's drawings.[2] This period of study and the absence from the metal-working facilities of Fane's New York studio resulted in a series of carved and constructed imaginary objects that recall the spirit of Taccola's drawings and appear to be mysterious implements of another world.[3]

Monument was created two years after the artist returned from Los Angeles and while it is less Taccola-inspired than some of the other pieces from that period, it does relate to the work he was doing in California. Devoid of the mechanical references present in much of the artist's sculptures from the mid-1990s, *Monument* still retains the metaphysical qualities inherent in all of the artist's work of the last decade. Typical of Fane's sculpture, there is something both familiar yet enigmatic about the piece and its monolithic presence, abstract form, and referential title all suggest an object of grave solemnity.[4] Indeed, *Monument* is an extremely personal work that was created after the loss of a close friend and inspired by a specific tombstone. Its sepulchral formality and stele-like composition allow it to transcend temporal constraints. As Barbara MacAdam has noted, "It's a touching reminder of continuity between the past and the present, tradition and modernity."[5] —MNP

1. Bill Barrette, *Machines of the Mind: Sculpture by Lawrence Fane*, exh. cat. (Richmond, VA: University of Richmond Museums, 2002), 21.
2. Lawrence Fane, "The Invented World of Mariano Taccola: Revisiting a Once-Famous Artist-Engineer of 15th-Century Italy," *Leonardo* 36 (2003): 135–143.
3. J. Bowyer Bell, "Lawrence Fane: Reimaging Memory," *Review: The Critical State of Visual Art in New York* (March 15, 1999): 1.
4. Jonathan Goodman, "Tom Doyle and Larry Fane," *Sculpture* 18 (September 1999): 68.
5. Lawrence Fane, email correspondence with the author, 8 January 2007. Also, Barbara A. MacAdam, *Lawrence Fane*, exh. cat. (New York: Kouros Gallery, 1999), 15.

ANDREW FORGE

(1923–2002)

ANA 1992; NA 1994

Fragment. Roman Torso, 1985–86
Oil on canvas
44 3/8 × 36 1/4 inches
NA diploma presentation, 1993
© 1993 Estate of Andrew Forge

Known not only as a painter, but also as an equally well respected critic and art historian, Andrew Forge has written on topics ranging from Claude Monet to Alberto Giacometti and Al Held. Forge was born in Hastingleigh, Kent, England and attended the Camberwell School of Art and Crafts (renamed Camberwell College of Arts), London, where he studied with the figurative painter William Coldstream and abstractionists Kenneth Martin and Victor Pasmore. Following his graduation in the late 1940s, Forge spent the next twenty years teaching painting at the University of London, first at the Slade School of Art and subsequently as the head of the Fine Arts Department at the prestigious Goldsmiths College. He moved to America in 1973 and took a one-year teaching position as visiting professor at The Cooper Union for the Advancement of Science and Art. The following year Forge became the associate dean at the New York Studio School and in 1975 entered the faculty at the Yale University School of Art, where he served as dean from 1975 to 1983.

In the 1950s Forge's work was representational and reminiscent of the style of his mentor, Coldstream. By the end of the decade, however, the artist felt as if he had exhausted all the possibilities of representational painting: "I couldn't decide on the most essential question of all, which was the relationship between the canvas and that which is depicted."[1] Forge eventually reached an impasse with his work and for six months could not paint. He had something of a revelation, however, when he visited America for the first time in 1963 and saw the work of the Abstract Expressionists and met the group around John Cage, including Jasper Johns, NA, Robert Rauschenberg, NA, and others. It was this experience that inspired his move toward abstraction.[2]

While Forge was influenced by the paintings of Jackson Pollock and Willem de Kooning, NA elect, he encountered in the States, he found Abstract Expressionism overwhelmingly romantic and instead channeled his impulse for abstraction into a much more controlled, what might even be called classical, format. *Fragment. Roman Torso* is from a series of works painted in the mid-1980s when the artist spent an extended period of time in Rome.[3] It is a typical example of Forge's mature style and illustrates his use of dots to create an infinitely subtle composition. While the artist's technique is similar to that of the Neo-Impressionists, Forge never intended to paint representationally in these works. Interested in perceptual psychology, he would commence without any preconceived ideas and apply the daubs of paint to create a densely woven fabric of metamorphosizing color.[4] As he stated in the entry form for the 1999 Annual exhibition: "The painting starts with a single dot and grows around it. Its beginning is abstract but as it grows it collects associations and suggestions."[5] The ultimate effect, as seen in *Fragment. Roman Torso*, is an eidetic image of great complexity. —MNP

1. "Andrew Forge in Conversation with Jacopo Benci and Silvia Stuckey," *891* 2 (July–December 1985): 25.
2. Ibid.
3. John Russell, "Exhalting the Dot in Singular Ways," *New York Times* 17 June 1996, 14.
4. John Hollander, Michael Kubovy, and Andrew Forge, *Andrew Forge*, exh. cat. (New Haven, CT: Yale Center for British Art, 1996), 10.
5. Andrew Forge, "Entry Form: 174th Annual Catalogue Information," n.d., National Academy Museum Archive.

HELEN FRANKENTHALER

(b. 1928)

ANA 1985; NA 1994

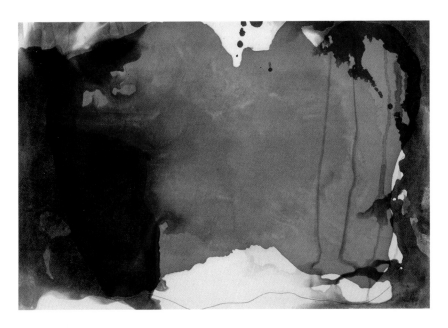

Causeway, 2001
Color spit-bite aquatint with soft ground on
 cream wove paper
EDITION: Artist's proof, 14/24
IMAGE SIZE: 21⁹/₁₆ x 31⁹/₁₆ inches
SHEET SIZE: 28½ x 37¾ inches
NA diploma presentation, 2002
© 2007 Helen Frankenthaler

A pioneer among revolutionaries, Helen Frankenthaler has been hailed as one of the principal vanguards of modern abstract art. The daughter of a New York State Supreme Judge, Frankenthaler received her initial artistic training at the Dalton School under the celebrated Mexican artist, Rufino Tamayo. In March of 1946 she entered Bennington College in Vermont and continued her studies under Paul Feeley, who introduced her to the spatial mechanics of Cubism. Such exposure motivated Frankenthaler "to push the development of Cubism so that line per se disappeared."[1] At the suggestion of critic Clement Greenberg, Frankenthaler spent three weeks in 1950 under Hans Hofmann's tutelage, learning his "push-pull" theory that used contrasting colors to balance flatness and depth. A year later she had her first solo exhibition at the Tibor de Nagy Gallery and formed close relationships with Jackson Pollock and Lee Krasner, whose paintings were having an increasing influence on her artistic output.

In 1952, at the age of twenty-three, Frankenthaler premiered her groundbreaking stain technique with the monumental canvas, *Mountains and Sea*. With no compositional predecessor, she transformed Pollock's calligraphic line into pure color and form, freeing abstract art from its script-like function and embracing color's translucent depth. Her uniquely intense yet graceful compositions were created by thinning pigment to the consistency of watercolor and applying it to an unprimed canvas. The process liberated paint from the constraints of the brush and allowed the inherent, amorphous characteristics of the medium to act out their intrinsic properties on the compositional field. Her innovation has been acknowledged as the umbilical link between the gestural paintings of Jackson Pollock and the Color Field works of Morris Louis.

Frankenthaler once stated, "I'd rather risk an ugly surprise than rely on things I know I can do."[2] With an unquenchable thirst for exploration, she began experimenting with printmaking in the early 1960s. *Causeway* is the result of a continual search, growth, and evolution. Like the meeting of primordial tissue, the print's veils of color float across the framed expanse, suggesting the mysterious depths of life's origin. Whereas her early work combined gesture with amorphous form, *Causeway* remains dedicated to the primary tenant of abstraction—truth to the medium. The overlapping colors seep into one another, integrating illusionistic space into clouds of pigment as they continually flow and expand beyond the material frame. Frankenthaler's earlier work sought to reconcile the dualities of nature, while *Causeway* embraces dissonance as a fundamental unit within nature. The composition's subject is the primal interaction of natural elements and the awareness of the primordial enigma that can only be realized after a lifetime of investigation. —MS

1. Barbara Rose, *Frankenthaler* (New York: Harry N. Abrams Inc., Publishers, 1971), 20.
2. Ibid., 105.

SONIA GECHTOFF

(b. 1926)

ANA 1993; NA 1994

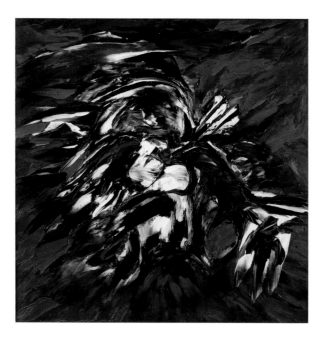

The Visitor, 1960–61
Oil on canvas
32 × 32 inches
Gift of the artist, 2006
© 2007 Sonia Gechtoff

Born in Philadelphia to the Russian émigré landscape painter Leonid Gechtoff, Sonia Gechtoff studied art in high school before winning a scholarship to attend the Pennsylvania Museum School of Industrial Art. The curriculum was geared toward commercial art, but Gechtoff also learned anatomy and drew from the model, which would have a lasting effect on her later abstract drawings.[1] The artist graduated with a bachelor's degree in 1950 and soon moved to San Francisco, where she enrolled for one semester in a printmaking class at the California School of Fine Arts in 1951.[2] She arrived in San Francisco at a time of great artistic ferment. Clyfford Still had recently left a five-year teaching stint at the school and in his wake were the resounding aftershocks of Abstract Expressionism. Gechtoff met and became friendly with the core group who would make up the Bay Area Abstract Expressionists including Elmer Bischoff, NA, Ernest Briggs, Hassel Smith, and others. Ultimately, she would develop a refined abstract style and she became one of the more prominent painters in San Francisco at the time.

In 1953 Gechtoff married fellow artist James Kelly, NA, whom she had met through her association with the CSFA. The couple were active participants in the burgeoning Bay Area art scene and exhibited frequently with other abstract artists at cooperative galleries the King Ubu, and its successor the Six. Both venues were also important centers for emerging Beat poets such as Allen Ginsberg, Michael McClure, and Jack Spicer.[3] In 1957 Gechtoff was selected for a solo exhibition at the M. H. de Young Memorial Museum and the following year she was chosen as part of the American pavilion at the Brussels World's Fair. At the time in San Francisco there developed a divisive split between the abstract artists and those who renounced abstraction and returned to representation, primarily Elmer Bischoff, NA, David Park, and later Richard Diebenkorn, NA. Unhappy with the environment, Gechtoff and Kelly moved to New York in 1958.[4]

By the late 1950s Gechtoff's work had significantly matured and began to exhibit a few distinct characteristics, as Susan Landauer and others have noted. *The Visitor*, while completely abstract, comes from a series of works in which the subject references a figure. As in other paintings from that group, the artist applied paint to the canvas exclusively with a palette knife. It was a technique for which she became known and an early review stated: "all [paintings] of the last two years evolve out of the brilliant palette knife work."[5] *The Visitor* is composed in sweeping, flame-like areas that seem to emanate from the center of the painting and reflect the artist's ongoing adaptation of a circular motif during these years.[6] It is most closely linked to a work by Gechtoff titled *The Visit*, which is a reference to Friederich Dürrenmatt's tragic-comedic existentialist play of the same title. The artist was fascinated by the notion of the female mythic figure at the time, and while neither painting is a visual representation of the female character, both can be seen within the larger context of a metaphorical representation.[7] —MNP

1. Sonia Gechtoff, interview with author, June 2, 2006, transcript in National Academy Museum Archive.
2. Susan Landauer, *The San Francisco School of Abstract Expressionism*, (Berkeley: University of California Press, 1996), 159.
3. Ibid., 163.
4. Gechtoff, interview with author, June 2, 2006.
5. Gerald Nordland, "Art," *Frontier* 10 (January 1959): 21.
6. John Loughery, *Sonia Gechtoff: Four Decades of Works on Paper, 1956–1995*, exh. cat. (Saratoga Springs, NY: Schick Art Gallery, Skidmore College, 1995), n.p.
7. Sonia Gechtoff, telephone interview with author, December 15, 2006. *The Visitor* also provided a precedent for a number of Gechtoff's later works, including *Troika* (1992) and *Goya's Ghost* (1998), which have similar metaphorical representations of the female figure. Sonia Gechtoff to author, 12 March 2007, National Academy Museum Archive.

ROBERT GOODNOUGH

ANA 1992; NA 1994

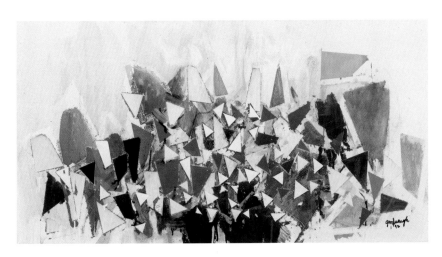

Battle One, 1992
Oil on canvas
18 x 34 inches
ANA diploma presentation, 1993
© Robert Goodnough

Considered by many a second-generation Abstract Expressionist painter, Robert Goodnough grew up in rural upstate New York and took classes with a local artist as a child. He won a scholarship to attend Syracuse University and after graduation was drafted into the army, serving briefly in the South Pacific during World War II. Prior to the war Goodnough's art was figurative. However, it was while he was stationed in New Guinea that the artist was first exposed to the modern art of Picasso and Mondrian illustrated in a magazine.[1] Following the war Goodnough moved to New York where he continued his studies with Amédée Ozenfant and soon thereafter with Hans Hofmann. Influenced by both artists, Goodnough has continued to work in a pluralism of styles that reflects both the discipline and control of Ozenfant and the expressiveness of Hofmann.

Goodnough began exhibiting in New York with his inclusion in the 1950 landmark exhibition New Talent organized by Clement Greenberg and Meyer Schapiro and held at the Kootz Gallery. Not nearly as influenced by the gestural approach to abstraction as some of his New York School colleagues, by 1952 Goodnough was experimenting with collage, and his work began to incorporate stronger geometric elements. Much of the artist's work at this time, as many have noted, took on a decidedly Cubist tendency of arranging geometric forms within the picture plane.[2] Greenberg, long a champion of Goodnough's work, wrote perceptively of the artist's use of layered geometric shapes in the composition: "they convey a wealth of force by slight-seeming means: the placing and proportioning of the clustered leaf-facets in relation to large areas of unmarked canvas; the microscopic spacing of the leaf-facets themselves; their changes of hue and value, their thickened surfaces, which lift from the canvas almost imperceptibly—that's how some of the best art of our time gets itself made."[3]

In Goodnough's painting of the 1970s and early 1980s his unmistakable clusters of triangle shapes were often situated within a large, neutral tone field, floating within the picture plane. These works retained the tactility of his work from the previous decades but did so in a more sparing way. By the mid-1980s, the artist returned to activating more of the negative space within the painting, a trend in his work that has continued. While he never completely abandoned the use of gesture, and sometimes incorporated it into his paintings, he is better known for his collage-like geometric works. *Battle One* is one of these paintings from the early 1990s that demonstrates the artist's interest in greater activation of the composition.[4] Inherently process-oriented, *Battle One*'s collage effect is most evident by the layering of white triangular shapes over those of red and blue. While he strives to elicit a reaction from the viewer, it is also the formal issues of painting with which the artist has grappled: "It was a matter of using each shape as I felt it, and trying to relate it to other shapes, or trying to create a conflict between the different shapes and resolve that tension."[5] —MNP

1. Ed McCormack, "Why is Robert Goodnough Still the Most Under-Rated Painter in America?" *Gallery & Studio* 7, no. 4 (April/May 2005): 10.
2. Martin H. Bush and Kenworth Moffet, *Goodnough* (Wichita, KS: Wichita State University, 1973), 29.
3. Clement Greenberg, *Robert Goodnough* (New York: ACA Galleries, 1993), 6.
4. *Battle One* is Goodnough's ANA diploma presentation. The Academy's Council would, in some instances, accept representative works in place of portraits for artists who were not necessarily portrait painters.
5. Matthew Rose, " 'It's Too Much Like Robert Goodnough's': An Interview" *Arts Magazine* 61, no. 8 (April 1987): 64.

STEPHEN GREENE

(1917–1999)

ANA 1980; NA 1982

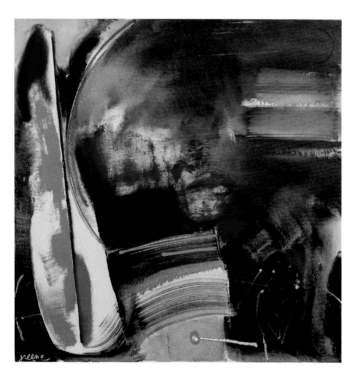

Night, 1982
Oil on canvas
30 ⅛ × 30 ⅛ inches
NA diploma presentation, 1983
© Estate of the artist

Stephen Greene came to abstraction only after an extended period as a representational painter. His early painting was influenced by classical antiquity, late Gothic, Northern European painters, and those of the early Sienese Renaissance. These figurative works were filled with emotion and existential anxiety and sought to convey a universal sense of tragedy, a characteristic that the artist would carry through to his later abstractions.[1] As the artist has stated: "The most important aspect of Greek art to my work has not been sculpture and drawings, the classical iconography, but what appears in Greek drama: the tragic sense."[2] Greene was born in New York and studied initially at the National Academy of Design and the Art Students League before enrolling at the University of Iowa under Grant Wood. Wood died in 1941 while Greene was a student there, and Philip Guston, ANA elect, was hired to replace him. As H. W. Janson has pointed out, Guston "impressed Stephen Greene more with his searching attitude than with the authority of his style."[3]

By the early 1960s Greene had abandoned representation in favor of a distinctive lyrical abstraction that synthesized a number of post-war abstract styles.[4] He eschewed many of his earlier influences in favor of something inherently self-referential: "At one point, I had to do away with any formal references to Renaissance painting in my work. I began to want the painting to refer back to itself, to its own space."[5] However, even by the middle of the 1970s, Greene's paintings retained the emotional content of his earlier figurative works, now articulated in an abstract mode.[6] One major distinction between Greene and many of his contemporary abstract colleagues is that while Greene abandoned the figure in his work, he never relinquished the importance of narrative.[7] The artist would continue to refine this type of abstraction until the end of his life.

Greene first exhibited at the National Academy in 1971 as part of a distinguished list of invited artists. He was also one of a large group of abstract painters elected to the Academy in the watershed year of 1980. He would continue to be a regular contributor to the Academy's Annuals until his death and in 1981 he won the Paul Puzinas Memorial Award for *Solus #7*. *Night* is a typical work by Greene from the 1980s. Its neutral ground is punctuated by slashing strokes of bright orange, red, and blue, while at the same time interspersed with broad washes of yellow, pink, orange, and blue. The painting received the Saltus Gold Medal when it was shown at the Academy's 158th Annual, and along with the painting by Esteban Vicente, NA, was highlighted in a review as some of the best work in the show: "the context [of the exhibition] makes good work stand out even more . . . like chocolate chips in a large, bland cookie."[8]　　　　　—MNP

1. H. W. Janson, "Stephen Greene," *Magazine of Art* 41 (April 1948): 129.
2. Stephen Greene, "The Tragic Sense in Modern Art," undated, Stephen Greene Papers, reel N70-37, Archives of American Art, Smithsonian Institution.
3. Janson, "Stephen Greene," 129.
4. Roberta Smith, "Stephen Greene, 82, Painter With Distinctive Abstract Style," *New York Times*, 29 November 1999, A23.
5. Stephen Greene, "Artist in America: A Case in Point," *Artist in America* 49 (1961): 84–85.
6. Martica Sawin, "Stephen Greene's Recent Paintings," *Arts Magazine* (September 1975): 83.
7. Debra Bricker Balken, *Stephen Greene: Painter and Mentor*, exh. cat. (Andover, MA: Addison Gallery of American Art, 2003), 4.
8. Grace Glueck, "In the Arts: Critics' Choices," *New York Times*, 17 April 1983, 104.

RICHARD HAAS

(b. 1936)

ANA 1993; NA 1994

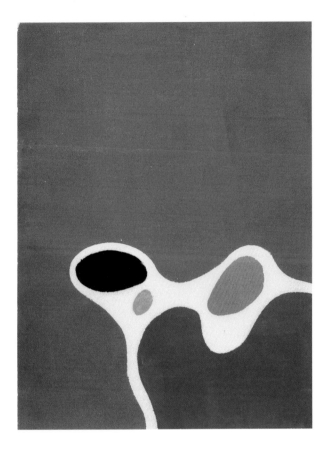

Blue Bursts In, 1966
Color woodcut on paper
EDITION: Artist's proof
IMAGE SIZE: 23⅞ x 17¾ inches
SHEET SIZE: 29¼ x 24½ inches
Gift of the artist, 2007
Art © Richard Haas/Licensed by VAGA,
 New York, NY

Known chiefly as a muralist and printmaker of highly detailed, realistic architectural subjects, Richard Haas worked as an abstract artist in painting and printmaking for a good portion of his early career. Born in Spring Green, Wisconsin, the artist was interested in architecture and spent two summers as a teenager working at Frank Lloyd Wright's Taliesin in 1955 and 1956. While there Haas had the opportunity to study Wright's drawings and watercolors, which had a lasting effect on him.[1] He attended the University of Wisconsin, Milwaukee (then Wisconsin State College) and studied art education as a viable alternative to pursuing a career as a fine artist. Haas recalled: "No one in their right mind would lie and tell you that you would make a living as an artist. It was just impossible. So you always had to have a hook."[2] Following college, Haas took a teaching position at a high school in Milwaukee, but after two years entered the graduate program at the University of Minnesota in 1961, graduating with an MFA in 1964.

After working in a gestural style that recalled many of the painters of the New York School, by the mid-1960s Haas began creating paintings, prints, and collages using a geometrically-based mode that emphasized large areas of color. By then he had accepted a teaching position at Michigan State University where Charles Pollock (older brother of Jackson Pollock) was also teaching and responsible for inviting critics and artists such as Clement Greenberg, Anthony Caro, Jules Olitski, NA, and Barnet Newman to come and speak. At the time, Haas was particularly interested in Edvard Munch and the German Expressionists and utilized their woodblock printing technique of cutting the block into sections and then reassembling them, inking each section a different color, and then printing them together as a unit. Like his paintings of this period, the artist recalled that the prints "became objects, as such. They were no longer windows into space, kind of the opposite of where I went later. But they were about flattening and almost projecting into the room, from a wall, with exciting and almost jarring color interplays."[3]

Blue Bursts In is a typical work during this period in Haas's career. He was prolific while at Michigan State (and continues to be), and his prints were shown in Detroit (where one was purchased by the Detroit Institute of Art), Chicago, and New York. The work's hard edges and broad geometric areas of saturated color recall the concurrent Color Field work of, Olitski, Frank Stella, NA elect, and others. Haas worked with both organic shapes as seen in this print and also more straight-edge geometric forms. These works subsequently led into his incorporation of the grid in the paintings done during the late 1960s that ultimately brought him to his renderings of the cast-iron façades of SoHo buildings, for which he is perhaps best known. Thus, while Haas's current work is representational, when seen in the context of his extensive career it is actually not far removed from his early abstractions.[4]　　　　　　　　　　　　—MNP

1. Marilyn Kushner, *The Prints of Richard Haas, 1974–2004* (New York: John Szoke Editions, 2005), 15–16.
2. Richard Haas interview with Avis Berman, September 15, 2004, National Academy Museum Archive. Reproduced with the permission of Richard Haas.
3. Ibid. The abstract prints were preceded by and in part grew out of a group of figurative woodblock prints Haas created in the early 1960s.
4. Haas never completely abandoned representation in his work and throughout the 1960s he constructed three-dimensional light boxes, which he still makes today. Kushner, *The Prints of Richard Haas*, 18.

RICHARD HUNT

(b. 1935)

NA 1999

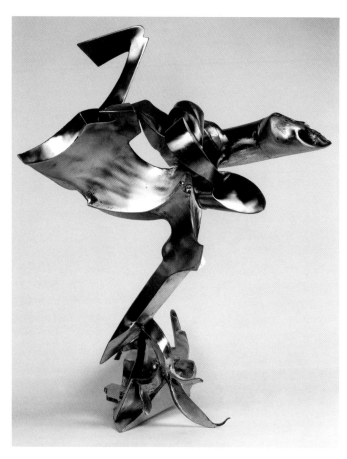

Offset, 2002
Stainless steel
38 × 28 × 24 inches
NA diploma presentation, 2002

Through his welded, cast, and extruded metal sculpture Richard Hunt has explored the possibilities of three-dimensional abstraction for decades. Born in Chicago during the Depression, Hunt enrolled in the School of the Art Institute of Chicago in 1953. It was during this same year that he was deeply affected by the direct metal welded constructions of Spanish sculptor Julio González, whose work he saw in an exhibition Sculpture of the Twentieth Century.[1] Soon thereafter Hunt taught himself to weld, and his prodigious talent was confirmed when the Museum of Modern Art purchased Hunt's *Arachne* in 1957 for its permanent collection. Additional early influences on his work include the linear forms of Surrealist painter, Roberto Matta, with whom Hunt briefly studied, the welded work of David Smith, the assemblage of Picasso, and the similarly lyrical direct metal work of Hunt's fellow Chicago sculptor, Joseph Goto, among others.[2] The artist's sculpture has never been derivative, however, and throughout the 1950s Hunt continued to utilize the potential expressiveness of found metal objects and industrial detritus, placing him at the forefront of the mid-century sculptural movement of the "junk" aesthetic.

Following his graduation from the School of the Art Institute of Chicago in 1957, Hunt traveled to Europe on a scholarship and in 1958 was drafted into the army, during which time he continued to work. He had his first solo exhibition in New York in 1958 at the Allen Gallery and has continued to exhibit regularly. While Hunt has always been inspired by and referred to nature in his sculpture, in the 1960s he moved away from his earlier calligraphic and corporeal efforts and toward a more monolithic approach.[3] Hunt's first museum retrospective exhibition was at the Milwaukee Art Museum in 1967, followed four years later by a retrospective at the Museum of Modern Art, New York that also traveled to the Art Institute of Chicago. Throughout the following two decades he increased the scale of his work and won dozens of public commissions.

Offset is part of a group of sculptures that signaled a return to a more lyrical approach to sculpture for Hunt. Hybridism or hybridity are terms that have long been used to describe the artist's work, and *Offset* is a prime example of how Hunt combines his interest in ancient forms with European and American modernism, African metalwork, and African-American history.[4] While completely abstract, *Offset* dances with fluid-like grace and appears almost as if it may have sprung from some primordial source. The enduring relevance of his artist statement from 1966 is a testament to his conviction: "In some works it is my intention to develop the kind of forms nature might create if only heat and steel were available to her."[5]

—MNP

1. Judd Tully, "Anvil and Acetylene," in *Richard Hunt*, exh. cat. (New York: Dorsky Gallery, 1989), n.p.
2. Lynne Warren, ed., *Art in Chicago, 1945–1995*, exh. cat. (Chicago: The Museum of Contemporary Art, 1996), 258.
3. William Lieberman, *The Sculpture of Richard Hunt*, exh. cat. (New York: Museum of Modern Art, 1971), 5.
4. International Art & Artists, *Richard Hunt: Affirmations* (Washington, D.C.: International Art & Artists, 1998), 11.
5. Lieberman, *The Sculpture of Richard Hunt*, 14.

ANGELO IPPOLITO

(1922–2001)

NA 2001

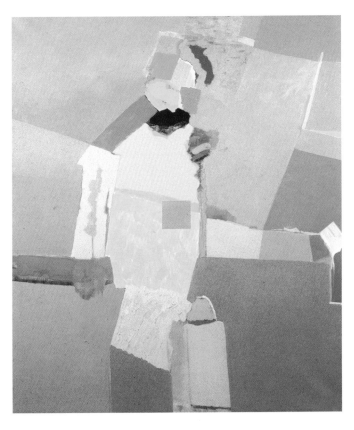

Roundabout, 1982
Oil on linen
66¼ x 58⅝ inches
NA diploma presentation; gift of Michael and
 Jon Ippolito, 2006

Angelo Ippolito was, along with Charles Cajori, NA, Lois Dodd, NA, William King, NA, and Fred Mitchell, a founding member of the Tanager Gallery, one of the earliest cooperative galleries in New York. Ippolito was born in St. Arsenio, Italy in 1922 and immigrated to America with his parents in 1931. As a child he studied art at the Leonardo da Vinci Art School and from 1942 to 1945 served in the army. Following his service, Ippolito returned to art by enrolling in the Amédée Ozenfant School of Fine Arts in New York from 1946 to 1947 before moving to the Brooklyn Museum Art School to study under John Ferren. Funded primarily by the GI Bill, Ippolito moved to Rome, Italy, at the end of the decade where he continued his studies at the Isituto Meschini with Italian abstractionist Afro Basaldella. It was not long after his return to the U.S., in 1952, that he helped found the Tanager Gallery, which was intended to be an extension of the artists' studios.[1]

Ippolito's work from the early 1950s are gestural abstractions that were stylistically linked to the Abstract Expressionist movement. While the artist admired the so-called "action painters" of the first generation of Abstract Expressionism, Ippolito was one of a number of younger artists who rejected the impassioned struggle that seemed to be embodied in their work. He felt that action painting had run its course, and noted that it "has gone on long enough to lose its risk. We know too well what can come out of it."[2] Instead, the artist explored a much more lyrical type of abstraction that art historian John I. H. Baur referred to as Abstract Impressionism, and linked him with Philip Guston, ANA elect, Hyde Solomon, and others.[3] By the mid-1960s the artist's work had taken a decidedly geometric turn that culminated in a series of nearly Minimalist works at the end of the decade. In the 1970s Ippolito returned to representation in a vaguely Cubist mode that would presage the synthesis of these many elements by the early 1980s.

Roundabout is from a series of paintings that was inspired by the landscape of upstate New York and completed between 1976 and 1985. Here he has combined the geometric elements of previous series of representational works with subtle passages of gesture that recall his paintings of the 1950s. The artist has employed a limited tonal range and broad areas of predominantly neutral tones overlayed with smaller areas of yellow, pink, and blue. Ippolito's application of geometric forms is interspersed with numerous areas of the softer lyricism to which Baur referred, and the palette has become more specific. As one scholar has noted, "in these mature abstractions the palette is more precise, as though Ippolito's discursion into representation in the intervening years recalibrated his 'color pitch'."[4] —MNP

1. Dore Ashton, "Art: Cooperatives Unite," *New York Times* 26 May 1960, 67.
2. As cited in Irving Sandler and Jon Ippolito, *Angelo Ippolito: A Retrospective Exhibition*, exh. cat. (Binghamton, NY: State University of Binghamton, 2004), 3.
3. John I. H. Baur, *Nature in Abstraction: The Relation of Abstract Painting and Sculpture to Nature in Twentieth Century American Art*, exh. cat. (New York: The MacMillen Company, 1958), 13.
4. Sandler and Ippolito, *Angelo Ippolito*, 19.

JASPER JOHNS

(b. 1930)

ANA 1990; NA 1994

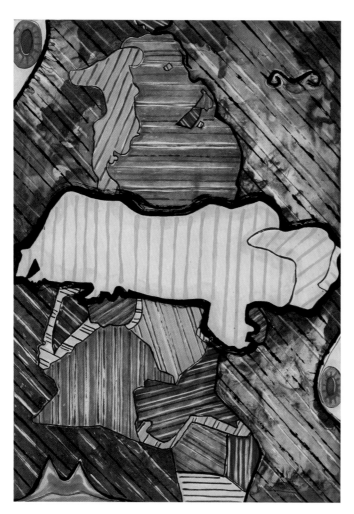

Green Angel, 1991
Color etching on Barcham Green Boxley paper
EDITION: 11/46
IMAGE SIZE: 25 1/2 x 18 1/16 inches
SHEET SIZE: 31 3/16 x 22 11/16 inches
NA diploma presentation, 1997
Art © Jasper Johns/Licensed by VAGA, New
 York, NY

One of the most prominent artists in America, Johns first became known for his use of motifs of targets, flags, and other everyday objects. Johns is largely self-taught, having only briefly attended the University of South Carolina and a commercial art school in New York. His career was launched in 1958 with a hugely successful solo exhibition at the Leo Castelli Gallery in New York. His close relationship with Robert Rauschenberg, NA, from 1954 to 1961 had an important impact on both artists' work, which would be influential in moving American art away from Abstract Expressionism towards figurative and Pop art subjects.

From the moment of its first display, critics have been drawn into the mystery of Johns's motif known as Green Angel. Indeed, its presence in over forty paintings, drawings, and prints testifies to its importance in the artist's oeuvre. While Johns appropriated images in his artwork for decades, Green Angel is the first motif he has steadfastly refused to identify, revealing only that it is indeed a tracing of another image,[1] and later revealing the source of the name. The term Green Angel refers to an iconographically mysterious figure in the sixteenth-century *Isenheim Altarpiece* that has no apparent formal relation to Johns's motif but that has produced scholarly speculation.[2] Significantly, Johns has drawn from the *Isenheim Altarpiece* in other of his works, such as the figures of the reclining soldiers used in his painting *Perilous Night* (1982; National Gallery of Art, Washington, DC). While critics have questioned Johns's motivation in keeping silent on the source of Green Angel, he has stated that his goal was not to provide an art historical riddle, but to explore how knowing or not knowing the source of an image affects the way one sees it.

This print was the subject of its own exhibition earlier this year at the San Diego Museum of Art, which featured a set of seventeen proofs that reveal the process of creating the print. Besides the central motif, it also incorporates the cross-hatching and disembodied eyes, nose, and mouth Johns uses in many of his other works. While the source of Green Angel still remains a mystery, it has been suggested that it derives from one of Max Ernst's many images of birds.[3] And indeed, the beak-like shape and its entwined form at the top and claw shape at right center do suggest many of Ernst's images. However, it is likely that the source is more obscure. Because the motif has been depicted by the artist in different orientations, upside down, flipped right to left, it becomes even more difficult to pin down its origin. And in the end perhaps it is more rewarding to heed the artist's intention and simply assess it at face value. —CMB

1. In a February 22, 1991 interview with Amei Wallach, printed in Kirk Varnedoe, ed., *Jasper Johns: Writings, Sketchbook Notes, Interviews* (New York: The Museum of Modern Art, 1996), 259.
2. Joan Rothfuss, *Past Things and Present: Jasper Johns since 1983*, exh. cat. (Minneapolis: Walker Art Center, 2003), 31.
3. Mark Rosenthal, "Jasper Johns," exhibition review, *Burlington Magazine* 139 (January 1997): 67.

WOLF KAHN

(b. 1927)

ANA 1979; NA 1980

Sienese Countryside, 1963
Oil on canvas
27½ x 39½ inches
Gift of the artist, 2006
Art © Wolf Kahn/Licensed by VAGA, New
 York, NY

Known primarily for his radiant landscapes of trees and New England barns, Wolf Kahn, as a young artist in New York in the 1950s, witnessed the pervasiveness of Abstract Expressionism. Kahn was the fourth child born to a Jewish family in Stuttgart, Germany and from a very young age showed artistic promise. He escaped persecution in his home country through the Kindertransport rescue missions, and lived with two separate families in England before soon joining his family in the U.S. Following his graduation from the High School of Music and Art in New York he enlisted in the navy for one year. In 1946 he briefly attended Stuart Davis's classes at the New School before enrolling in the Hans Hofmann School of Fine Arts.[1] The experience would play a seminal role in Kahn's art, and he recalled, "We [the Hofmann students] felt we were learning the essence of modernism, art stripped of everything extraneous. What remained was its esthetic/philosophical foundation, its raison d'être."[2]

In the early and mid-1950s Kahn was working in an expressionistic yet representational style that was somewhat indebted to Chaim Soutine. He was included in the Fifth Annual Exhibition of Painting and Sculpture at the Stable Gallery in 1955, along with many prominent abstract artists of the decade. During this time Kahn spent his summers in Provincetown with Hofmann and other artists. It would have a lasting effect on him, and he recalled that in 1956 he "was in the midst of changing painting styles, [and] involved that summer in rediscovering pointillism."[3] In December 1956, Kahn joined painter Emily Mason, NA, whom he would soon marry (in March the following year), on a trip to Italy. There multiple influences would take hold, and he was deeply affected by the work of Giorgio Morandi, while his own work became increasingly abstract, more tonal and decidedly less chromatic in its palette.[4] By the early 1960s, soon after he and Mason returned to the States, representation had all but disappeared from his work.

A Fulbright fellowship in 1962 allowed Kahn to return to Italy to paint, and *Sienese Countryside* dates from this period. It is a referential landscape infused with the gestures of the New York School and verges on complete abstraction. During this period of approximately seven or eight years this abstract trend was symptomatic of Kahn's work, and in his own words he was "using the language of abstraction to play my own games."[5] By the mid-1960s, recognizable subject matter and a more varied palette reemerged. Kahn participated in the discourse surrounding abstract versus representational painting at mid-century and was in contact with many of the prominent New York School artists. Even though he has worked representationally for decades, Kahn has noted that the work of abstract painter Mark Rothko encouraged him "to carry the essential idea of radiance . . . into the way I view the problems of landscape."[6] —MNP

1. Justin Spring, *Wolf Kahn* (New York: Harry N. Abrams, Inc., 1996), 15. Kahn ultimately graduated with a BA from the University of Chicago.
2. Wolf Kahn, "Hofmann's Mixed Messages," *Art in America* 78 (November 1990): 189.
3. *Wolf Kahn in Provincetown*, exh. cat. (Provincetown, MA: Provincetown Art Association and Museum, 2006), n.p.
4. Martica Sawin, *Wolf Kahn: Paintings and Pastels*, exh. cat. (New York: Grace Borgenicht Gallery, 1985), n.p.
5. As cited in Spring, *Wolf Kahn*, 55.
6. Wolf Kahn, "Trying to Justify Landscape Painting," delivered at the National Academy of Design, May 16, 1987, typescript, National Academy Museum Archive.

JAMES KELLY

(1913–2003)

NA 1995

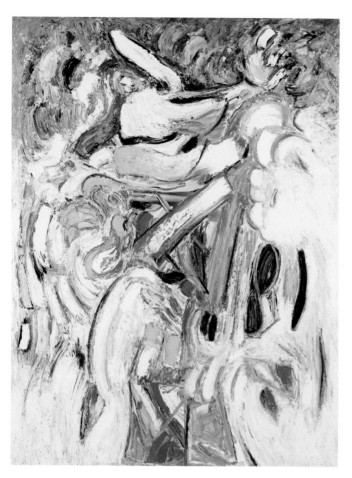

Hurly-Burly, 1991
Oil on canvas
40 × 30 inches
NA diploma presentation, 1996
© 1996 Sonia Gechtoff

Despite the recent departure of Clyfford Still from the Bay Area in 1950, the year James Kelly arrived, Abstract Expressionism was still in full bloom and a pervasive force. Kelly was born in Philadelphia and attended the Pennsylvania Museum School of Industrial Art there in 1937 followed by classes at the Pennsylvania Academy of the Fine Arts. His first exposure to European modernism was at the Philadelphia Museum of Art and in 1941 he won a scholarship to study at the Barnes Foundation. Study at the Barnes brought him into close contact with artists such as Matisse, Miró, Picasso, and van Gogh, whose work would come to have a great impact on Kelly.[1] Enlisting in the air force shortly after Pearl Harbor, Kelly spent four years serving as a technical sergeant, returning to Philadelphia after being discharged in 1945. In 1950, feeling the East Coast insular, Kelly traveled to California with his friend, painter John Lynch.[2]

Kelly arrived in San Francisco at the height of West Coast Abstract Expressionism. As a GI Bill student Kelly enrolled in the progressive California School of Fine Arts. In 1953 Kelly met and soon married painter Sonia Gechtoff, NA, who had arrived in San Francisco in 1951, and together they became an integral part of the Bay Area avant-garde. The couple participated in the earliest artist-and-poet-run cooperative galleries such as King Ubu and the Six Gallery. These served as venues for exchange between painters and poets such as Robert Duncan, Allen Ginsberg, and Jack Spicer, and would be visited by writers such as Jack Kerouac during trips to San Francisco.[3] By the mid-1950s Kelly was receiving some critical attention and he was developing more of an interest in the physical qualities of the materials.[4] In 1957 he taught drawing and painting at the University of California, Berkeley and won first prize for painting at the San Francisco Museum of Art's Annual exhibition the following year.

In 1958 Gechtoff and Kelly moved from San Francisco to New York and five years later each artist was awarded fellowships to attend the Tamarind Lithography Workshop in Los Angeles. Kelly's work has been described as "volcanic gesturalism in which boundless energy was suggested through the accumulation of dense swatches and slabs of color that drove in surging, rhythmic trajectories across his canvases."[5] Indeed, *Hurly-Burly* exhibits the artist's interest in tactility of materials through the combination of small animated areas of rapidly applied paint with broad sweeps of various colors using the palette knife. Like many of Kelly's best works, the painting hovers precipitously in the obscure threshold between abstraction and representation and can be understood within the context of the artist's lifelong intention of mediating between these two modes.

—MNP

1. Susan Landauer, *The San Francisco School of Abstract Expressionism* (Berkeley: University of California Press, 1996), 55.
2. Stacey Moss, *Mediating Abstraction and Figuration: The Paintings of James Kelly, 1953–1990*, exh. cat. (Belmont, CA: The Wiegand Gallery, College of Notre Dame, 1990), n.p.
3. Landauer, *The San Francisco School of Abstract Expressionism*, 162–63.
4. David Acton, *The Stamp of Impulse: Abstract Expressionist Prints*, exh. cat. (Worcester: The Worcester Art Museum, 2001), 112.
5. Thomas Albright, *Art in the San Francisco Bay Area, 1945–1980* (Berkeley: University of California Press, 1985), 52.

GYORGY KEPES

(1906–2001)

ANA 1973; NA 1978

Native Fragments, 1972
Oil and sand on canvas
50 1/4 x 40 inches
NA diploma presentation, 1979
© Estate of Gyorgy Kepes

Hungarian-born Gyorgy Kepes was perhaps best known as a photographer during the early part of his career and later as the founding director of the Center for Advanced Visual Studies at the Massachusetts Institute of Technology. Kepes was born in Selyp, Hungary and as a boy he moved with his family to Budapest. In 1924, he enrolled in the Royal Academy of Fine Arts, where he initially studied painting. While a student, Kepes became acquainted with a group of cultural and social revolutionary artists and poets who introduced him to the avant-garde works of Russian Futurism, Suprematism, and Constructivism. He soon joined the group, known as "Munka" or "Work," and by the late 1920s this exposure to revolutionary ideals contributed to Kepes's abandoning painting altogether in favor of light-based media such as photography, photomontage, photograms, and film.[1] He believed that these media most directly addressed the rapidity of change in modern life, yet as they relied on light for production, still retained an inherent connection to nature.[2]

Kepes moved to Berlin to work with Bauhaus artist and photographer Lázló Moholy-Nagy in 1930 and in 1937 immigrated to America to teach at the newly established Chicago Bauhaus. Kepes also became known as a theorist who, for the rest of his life, explored the relationship between art and science. The first of his many publications, *Language of Vision* (1944), was partially responsible for his appointment to establish a program in visual design at MIT in 1945. Kepes returned to painting around 1950 after nearly a two-decade absence and for the rest of his life created enigmatic works that often teeter on the edge of abstraction. In 1967 he founded the Center for Advanced Visual Studies at MIT, where visual artists could work closely with scientists and engineers.

Native Fragments is a typical work by Kepes from the early 1970s with its earth tone palette and liberal application of sand. The artist often applied sand to a canvas in order to build up the surface and give it an inherent three-dimensionality. While this technique, combined with abstract elements, recalls similar practices by some Abstract Expressionists, Kepes's works lack impulsive gesture and instead appear much more methodical in their creation. *Native Fragments* illustrates the artist's interest in the dialectical nature of life. It recalls a landscape, and its topographical nature is at once reminiscent of both a macrocosmic aerial view and a revealed microcosmic world. Striving for the combination of seemingly disparate elements was a lifelong goal of Kepes and it was through his work that he hoped to communicate something about the universal human condition, noting in 1965 that "Artists are living seismographs, as it were, with a special sensitivity to the human condition. They record our conflicts and hopes, and their immediate and direct response to the sensuous qualities of the world help us to establish an entente with the living present."[3] —MNP

1. Judith Wechsler and Jan van der Marck, *Gyorgy Kepes, The MIT Years: 1945–1977* (Cambridge, MA: MIT Press, 1978), 7–8.
2. Elizabeth Finch, "Languages of Vision: Gyorgy Kepes and the "New Landscape" of Art and Science" (PhD diss., The City University of New York, 2005), 7.
3. Gyorgy Kepes, ed., *Structure in Art and in Science* (New York: George Braziller, 1965), i.

KAREN KUNC

(b. 1952)

ANA 1993; NA 1994

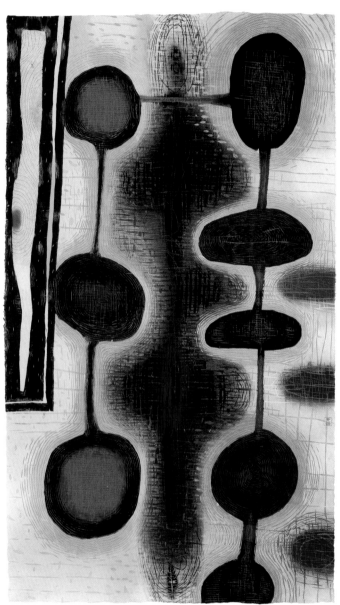

Broken Code, 1999
Color woodcut on cream laid paper
EDITION: 8/20
IMAGE SIZE: 42 x 23 $^{15}/_{16}$ inches
SHEET SIZE: 42 x 23 $^{15}/_{16}$ inches
Gift of the artist, 2004
© 1999 Karen Kunc

Color woodcut printing has been the primary medium of Karen Kunc for nearly thirty years. A Nebraska native, Kunc studied printmaking at the University of Nebraska and after graduation continued her education at Ohio State University, receiving her MFA in 1977. She arrived at working with woodcuts circuitously after initially exploring etching, silkscreen, and lithography. Kunc has been able to creatively refine the woodcut technique, the oldest type of printmaking, to produce abstract works that are not only deeply imbued with emotional, natural, and historical references, but are also works of very high technical skill. According to the artist, her woodcut prints are the product of a very personal reaction to forces in the outside world: "In my work, these formal ideas become symbolic abstractions, suggestive of landscape, unusual structures, or plant forms. . . . And the resulting artwork is a way to capture the creative choices, intensifying remembrances and concepts which become a subtext about the artist/creator and studio actions."[1]

Kunc uses a woodcut technique known as the color reduction process. Instead of using multiple carved blocks, one for each color, the reduction technique generally uses only one block to create the image. Kunc prefers birch or mahogany veneered plywood in which to carve her designs. The process involves numerous steps, and she often begins with stencils to create the initial design of the work, carving away areas of the block and inking only those specific areas with one or more colors. The print is then run through a press to create the first part of the impression. After carving and inking different areas of the block she runs it through the press again, adding new imagery to the print. This process may be repeated numerous times, and Kunc's prints often have forty or more different colors in them.

Kunc's work combines European modernism with traditional Japanese printmaking. By synthesizing forms that are reminiscent of both German Expressionism of the early twentieth century and seventeenth-century Japanese *ukiyo-e* prints she is able to create works of great subtlety and complexity. She has, according to one art historian, "affirmed links to Japanese pictorial design in her practice of abstraction from nature, sophisticated play of color, and complex integration of line, patter, and rhythmic motion within a composition."[2] *Broken Code* is a lattice of repeated organic shapes that are at once referential to nature and suggestive of enigmatic ciphers. The work itself becomes something of a cryptograph, and as others have noted, the result is a print that does not replicate natural forces but instead becomes an analogy to their processes.[3] —MNP

1. Karen Kunc, artist statement, January 15, 1999, National Academy Museum Archive.
2. Janet Farber, *20/21: Karen Kunc*, exh. cat. (Omaha: Joslyn Art Museum, 1995), n.p.
3. Lenore Metrick, *Karen Kunc: Woodworking: Process as Content*, exh. cat. (Fort Dodge, IA: Blanden Memorial Art Museum, 2001), 5.

VINCENT LONGO

(b. 1923)

NA 1997

Untitled, 1995
Acrylic on wood panel
35 1/8 x 32 inches
NA diploma presentation, 1998
© Vincent Longo

Painter and printmaker Vincent Longo has investigated the possibilities of working within the matrix of a grid for more than forty years. Orphaned at the age of two, Longo lived in a Catholic boarding school before being adopted as a teenager by a relative in Brooklyn. He attended Textile High School, where he studied commercial art and soon befriended Edmond Casarella, NA, an older artist who would become a mentor to him. After graduating from high school, Longo enrolled in evening classes at The Cooper Union for Advancement in Science and Art, following Casarella.[1] The late 1940s was a period in which philosophical ideas were very much part of the artistic discourse. It was at Cooper Union, and particularly through the lectures of Leo Katz, that Longo first became introduced to Asian philosophies, the ideas of Carl Jung, and Theosophy, all of which began to influence his work. In 1951, Longo received a Fulbright grant and the following year traveled to Florence with his then wife, artist Pat Adams, NA. In Italy he conducted his earliest investigations into abstraction, manifested as a study of archetypal motifs in art and architecture and their use in a religious setting.[2]

In 1955 Longo was hired to teach printmaking at the Brooklyn Museum Art School and the following year he and Adams, who had just won a Fulbright, traveled to France to study Neolithic sites in Brittany. The totemic abstractions that Longo and Adams witnessed confirmed for them the efficacy and universality of abstraction as a powerful mode of visual communication.[3] Upon their return to the U.S., Longo took a teaching position at Bennington College, where he would stay for the next ten years. His work from the 1950s recalls the gestural explorations of Abstract Expressionism, but by the mid-1960s he began to incorporate the grid into his work, using it as a framework for abstraction, and often incorporating circle and square motifs. This would provide the foundation for his work over the next four decades: "The grid has been a constant in my work since the 60's but the paintings are not about grids—they have more to do with reconciling oppositions of form: hard—soft, all-over—central, flatness—spatial illusions, etc."[4]

Untitled is divided into quadrants and combines two variations on the grid with a limited tonal range of yellows and greens. While his work is sometimes mistakenly referred to as serving a decorative function, given its repetition of pattern, the repeated geometric shapes are intended instead to initiate a contemplative experience in the viewer.[5] For Longo, abstraction is a transcendent visual mode and one that is more reflective of an inner nature than any outside reference.[6] As the artist has stated, abstraction is "intended to reflect, represent and present something other than, or more than, a grid or a lattice, suspended circle/square central construct. The viewer is meant to be lead to an affective state of concentration in which the visual means receded and their contents are unconcealed."[7] —MNP

1. Anthony Panzera, *Vincent Longo: Reflections on Abstraction*, exh. cat. (New York: Hunter College, 2003), 14.
2. Ibid., 20.
3. Ibid.
4. Vincent Longo, artist statement, January 15, 1999, National Academy Museum Archive.
5. David Acton, *The Stamp of Impulse: Abstract Expressionist Prints*, exh. cat. (Worcester, MA: Worcester Art Museum, 2001), 192.
6. Panzera, *Vincent Longo*, 21.
7. Vincent Longo, "Origins," in Marthe Keller, ed., *On Edge* (New York: American Abstract Artists, 2006), 113.

ROBERT MANGOLD

(b. 1937)

NA 2004

Frieze Study I, 1994
Graphite on two sheets of paper
22¾ × 30 inches each sheet
NA diploma presentation, 2005
© 2007 Robert Mangold/Artists Rights
 Society (ARS), New York

Elegant simplicity and a rigorously classical geometry have been hallmarks of Robert Mangold's work for more than forty years. Mangold was born outside of Buffalo, New York and began his studies at the Cleveland Institute of Art. In 1958, the artist experienced a revelation when he saw the work of the New York School painters, in particular Adolph Gottlieb, Barnett Newman, Mark Rothko, and Clyfford Still.[1] Later that year, Mangold attended summer classes at Yale University and despite his reticence over its Josef Albers-based curriculum, enrolled there in 1960. Yale was a crucible of creativity during these years and his instructors were Alex Katz, NA, Jon Schueler, NA, and Jack Tworkov, while fellow students included future Academicians, Brice Marden, Chuck Close, Rackstraw Downes, and Janet Fish, among others. Mangold graduated with a BFA in 1961 and completed his MFA in 1963.

In 1962, Mangold moved to New York with his wife, Sylvia Plimack Mangold, NA, (who had also been a student at Yale), where he worked at the Museum of Modern Art, bringing him into daily contact with some of the most influential modern and contemporary art. By the mid-1960s Mangold was exhibiting architectonic constructions that resembled sections of walls and recalled Donald Judd's declaration that: "Half or more of the best new work in the last years has been neither painting nor sculpture. Usually, it has been related, closely or distantly, to one or the other."[2] It was at this moment of dogmatic Minimalist rhetoric, however, that Mangold was drawn further into painting and began working on shaped monochromatic canvases. In 1971 he was honored with a solo exhibition at the Guggenheim Museum and throughout the decade his work took on an increasingly Vitruvian connotation through the combination of shaped canvases with circles and ellipses.[3] Architectonic qualities reappeared in the early 1980s through his combination of rectangular canvases to form colorful shapes in the +, X, and *Color Frame* series, and in the succeeding decade the artist returned to a more reductive vocabulary of ellipses and shaped canvases.

Drawing is critical to Mangold's working method and an important part of his painting process. Often initially creating a small sketch for a work, the artist will enlarge it to medium scale before ultimately realizing it in larger scale. *Frieze Study I* comes from a series of drawings executed in the mid-1990s that followed on ideas of the arabesque he was pursuing in his *Curled Figure Paintings* of the same period. These drawings also served as a precursor to his current *Column Series* paintings.[4] In *Frieze Study I* two sheets of standard-sized paper are joined at their edges, recalling a similar practice the artist used in the 1960s with plywood and masonite. Mangold has created a gray trapezoid shape that increases in height from left to right and is overlaid with a continuous line of four graceful, vertically-oriented loops that at once suggest a music like cadence as well as a graceful, rhythmic physical movement. —MNP

1. Hildebrand Diehl, Volker Rattemeyer, et al., *Robert Mangold* (Wiesbaden, Germany: Museum Wiesbaden, 1998), 148.
2. Donald Judd, "Specific Objects," *Arts Yearbook* 8 (1965); reprinted in *Donald Judd: Complete Writings, 1959–1975* (Halifax: Nova Scotia College of Art and Design; New York University Press, 1975), 181.
3. Richard Schiff, Robert Storr, Arthur C. Danto, and Nancy Princenthal, *Robert Mangold* (London and New York: Phaidon Press, Inc., 2000), 91.
4. Robert Mangold, telephone conversation with author, March 14, 2007.

LEO MANSO

(1914–1993)

ANA 1979; NA 1981

Kerouan I, 1977
Acrylic on canvas
49⅞ x 39⅞ inches
NA diploma presentation, 1984

Known as a painter, collagist, and graphic artist, Leo Manso was born in New York and after graduating from high school followed a traditional art curriculum. He enrolled in the evening antique drawing class at the National Academy of Design from 1930 to 1931, and subsequently studied drawing at The New School for Social Research until 1933. In 1948 Manso was invited to exhibit with the American Abstract Artists group at their annual exhibition (he would join the group in 1955). It was also around this time that the artist began to summer in Provincetown, Massachusetts, where he exhibited with artists such as Hans Hofmann, Jackson Pollock, and Adolph Gottlieb. In 1953 Manso co-founded the 256 Gallery in Provincetown along with Will Barnet, NA, Byron Browne, Peter Busa, Seong Moy, and others.

Manso first became interested in collage around 1955 when making a correction on a ruined drawing.[1] This particular aesthetic would permeate his work for the rest of his life, leading his friend Robert Motherwell, ANA, to write: "One of collage's masters during the past decade is Leo Manso. . . . Seductively beautiful as the work is at first sight, it holds its own like iron, a visual poetry that never compromises, never loses its inner life."[2] Indeed, visual poetry is an apt description of Manso's collages as many are works of subtle beauty layered in both a visual and metaphorical sense. Manso was extremely sensitive to societal conditions and aware of the inherent responsibilities of the artist, and his work was often a response to or reflection of these conditions. He wrote: "To be an artist one is obligated to investigate the human condition. To do this one must have curiosity, continually growing knowledge, and courage, for often the conclusions discovered are not conventional or convenient, and the artist must stand up for his discoveries."[3] The formal elements of his compositions had great significance for Manso and in his search to find a universal abstract language Manso wrote that he "went through considerable experimentation with collage and assemblage hoping to reach out to new technical alternatives to the brush. . . . I limited my pictorial vocabulary to the circle and the square, and their variants."[4]

Manso was an intrepid traveler, visiting Mexico, Africa, India, Nepal, and Europe. His first trip to Africa was in the early 1970s, and in 1975 he traveled to Tunisia with fellow artists Joseph De Martini, NA, Michael Lekakis, and Henry Rothman. With Rothman, Manso retraced the route that artists Paul Klee and August Macke took in 1914 through Tunisia and based the subsequent series of works on what he saw there. He stated that two themes ran through his work: "The distillation of landscape experience is one . . . the other—a symbolic concretion of philosophic values."[5] *Kerouan I* is one of the larger works from this series and incorporates Manso's collage aesthetic into this painting while combining these two themes. Kerouan, or Kairouan, is a Muslim holy city and pilgrimage site in Tunisia, and the crenellated walls and archways of some of its buildings are suggested in Manso's repeated block forms and large circular element. The Arabic script is fragmented and rotated ninety degrees to the right. Only partially legible, it appears to refer to the word "Arabic" (in the 5th line) and was used by Manso as ornamentation to elicit a sense of enigmatic exoticism. —MNP

1. Leo Manso, *Leo Manso: A Retrospective of Four Decades, 1952–1992*, exh. cat. (New York: The Art Students League of New York, 1992), n.p.
2. Ibid.
3. Leo Manso, artist statement, 1979, National Academy Museum Archive.
4. Leo Manso, "The Circle and the Square," 1971, typescript, reel 34, Archives of American Art, Smithsonian Institution.
5. Leo Manso, n.p.

EMILY MASON

(b. 1932)

NA 1999

For a Moment, 1996
Oil on canvas
24 x 24 inches
NA diploma presentation, 2000
Art © Emily Mason/Licensed by VAGA,
 New York, NY

Throughout her nearly fifty-year career, Emily Mason has explored the infinite possibilities of abstract painting through color and gesture. The daughter of Alice Trumbull Mason, a founding member of the American Abstract Artists group, Mason grew up in New York City during the heyday of Abstract Expressionism. As a child in this environment she wondered not *whether* she would be a painter, but instead what *type* of painter she would be.[1] After graduating from the High School of Music and Art she attended Bennington College briefly before returning to New York to continue her studies at The Cooper Union for Advancement of Science and Art. Mason's color sense was shaped, in part, during a residency at the Haystack Mountain School of Crafts, where the lectures by Jack Lenor Larsen on color had a profound influence on her.[2] Color has remained as her true métier.

In 1956 Mason won a Fulbright grant and traveled to Venice to paint. Prior to her departure, she had met another young painter, Wolf Kahn, NA, who would soon join her in Italy, and in 1957 the two were married. By the late 1960s Mason had moved away from the agitated gesture of her early work and was layering sweeping chromatic strokes over broad areas of color. She began teaching at Hunter College in 1979 and in an attempt to encourage her students to be free of the conscious mind used as part of her curriculum *Drawing from the Right Side of the Brain*.[3] That same year Mason's painting, *August Burning Low*, was the first abstract work purchased through the Ranger Fund. The automatic technique, combined with her interest in color, was recognized by artist and critic Louis Finkelstein, who identified it as an important strain of abstract painting. He wrote: "I call this direction 'color automatism,' and think it a vein of artistic production, which, while its roots are clear, remains insufficiently explored, and she is a good representative of some of its possibilities."[4]

Layered works such as *For a Moment* recall at once the placid broad areas of Color Field painting as well as the frenetic energy and gesture of Abstract Expressionism, and her work has been described as a link between the New York School and later developments of abstract painting.[5] The process of painting is essential to Mason, and, working intuitively, she often paints on the floor and from all sides of the canvas.[6] *For a Moment* combines Mason's interest in gesture and color, and, as David Ebony has pointed out, evokes the Aristotelian notion of the fifth element. A complement to the four elements of earth, air, fire, and water, the fifth element is a mysterious metaphysical substance and one that Aristotle believed filled the universe beyond the terrestrial sphere. Mason's technique of layering gestural areas over those of broad color and the combinations of complementary colors in *For a Moment*, in addition to the work's title, suggest meaning beyond the surface of the canvas.

—MNP

1. Bill Scott, *Emily Mason*, exh. cat. (New York: M B Modern, 1997), n.p.
2. David Ebony, *Emily Mason: The Fifth Element* (New York: George Braziller, 2006), 15.
3. Betty Edwards, *Drawing on the Right Side of the Brain: A Course in Enhancing Creativity and Artistic Confidence* (Los Angeles: J. P. Tarcher, 1979). Emily Mason, interview with Laura Beiles, May 19, 2005, National Academy Museum Archive.
4. Louis Finkelstein to James Bohary, August 28, 1998, National Academy Museum Archive.
5. Ebony, *Emily Mason*, 12.
6. Carl Little, "The Art of Emily Mason," *Art New England* 27 (December 2005/January 2006): 25.

ROBERT MOTHERWELL

(1915–1991)

ANA 1990

Automatism Elegy (State I White), 1980
Lithograph on white Arches Cover paper
EDITION: 40; Artist's proof III/VIII
PLATE SIZE: 4 11/16 x 9 15/16 inches
SHEET SIZE: 17 13/16 x 22 1/16 inches
ANA diploma presentation as a posthumous
 gift of the Dedalus Foundation, Inc., 1996
 Art © Dedalus Foundation, Inc./Licensed
 by VAGA, New York, NY

A central figure of the Abstract Expressionist group, Robert Motherwell also worked extensively in printmaking over three decades. He initially studied at the Otis Art Institute in Los Angeles and later at Stanford University, Harvard University, and Columbia University. In the early 1940s he befriended Roberto Matta and other European Surrealists in New York and in 1944 had his first solo exhibition at Peggy Guggenheim's Art of This Century Gallery. In 1948, along with William Baziotes, David Hare, Barnett Newman, and Mark Rothko, he was a founder of The Subjects of the Artist School in New York, a short-lived group concerned with subject matter in abstract art that eventually evolved into the Club. In the summers of 1945 and 1951 Motherwell taught at the experimental Black Mountain College, North Carolina and throughout the 1950s he was on the faculty at Hunter College, New York.

Motherwell is perhaps best known for his *Elegy to the Spanish Republic* series, consisting of over 140 large paintings begun in 1949. These are typically composed of vertical bars juxtaposed with oval shapes in black against a white background. The abstract shapes are intended to be visual metaphors of loss and represent the tragic effects of the Spanish Civil War of the 1930s. His first concentrated effort in printmaking in the 1960s was the direct result of trying collaboration as a means to escape a creative block. At that time, his working relationship with printer Irwin Hollander in New York City provided the needed boost. Motherwell has said of this period, "I had always instinctively loved working on paper, but it was the camaraderie of the artist-printer relationship that tilted the scale definitively."[1] Collaboration and the Surrealist concept of automatic drawing, unimpeded by the conscious mind, are two important components of *Automatism Elegy*.

While it is most obviously related to the *Elegy* series, this print has a more specific context, evident from the circumstances of its creation. The aluminum lithographic plate used to print *Automatism Elegy* was initially made for a very similar two-plate lithograph titled *Altamira Elegy*, created for the deluxe edition of the 1980 book *Reconciliation Elegy: A Journal of Collaboration* presented by E.A. Carmean, Jr. The book chronicles the commission and collaborative execution of Motherwell's *Reconciliation Elegy* for the newly constructed East Building of the National Gallery of Art. Instead of reproducing the painting in the lithographic medium for the book, Motherwell continued to develop the motif, adding the association of the primal quality of the cave paintings of Altamira, Spain through its title. *Altamira Elegy* and *Automatism Elegy* can be seen as an attempt to overcome the artist's dissatisfaction with the painting, which he felt lost its monumentality when seen in the museum, but "is alive close up."[2] Each of the lithographs translates the liveliness of the painting into a work on paper of small scale, which must be viewed up close. —CMB

1. Stephanie Terenzio, "Introduction: Collaboration as Self-Transcendence," in *The Painter and the Printer, Robert Motherwell's Graphics, 1943–1980* (New York: American Federation of Arts, 1980), 13.
2. Robert Motherwell, et al., *Reconciliation Elegy: A Journal of Collaboration presented by E.A. Carmean, Jr.* (New York: Rizzoli, 1980), 79.

JULES OLITSKI

(1922–2007)

ANA 1992; NA 1994

Salome Rock, 1990
Acrylic on canvas
48 x 24 inches
ANA diploma presentation, 1993
Art © Estate of Jules Olitski/Licensed by
VAGA, New York, NY

A leading figure in the Color Field movement in the 1960s, Olitski was born in the Ukraine and came with his family to America as a young child. From 1940 to 1942 he studied at the National Academy of Design School, where he followed a traditional curriculum of drawing from casts of antique sculpture and from live models. Following World War II, the artist continued his education in Paris first at the Ossip Zadkine School and from 1949 to 1951 at the Académie de la Grande Chaumière. It was there that Olitski, in a search for something more satisfying than his earlier representational work, began to paint abstractly.[1] After his return to America and receiving a BA and MA from New York University, Olitski took a teaching position at Long Island University, C. W. Post campus, and by the end of the decade was painting thickly impastoed works that have been linked to *Art informel*—a European counterpart to Abstract Expressionism—most notably the work of Jean Fautrier.[2]

Soon abandoning the agitated gestural work of his first abstract style, Olitski began to find his mature artistic voice by the early 1960s and produced paintings that were instead created with broad areas of color—what would become known as Color Field painting. It was a time when many artists felt that Abstract Expressionism had run its course, and in addition to eliminating the mark of the painter's hand, many sought new methods and modes of working. To create his paintings, Olitski began to utilize a pneumatic spray gun to apply pigment to the canvas, allowing for subtle variations of intensity and chromatic blending.[3] Championed by formalist critics including Clement Greenberg and Michael Fried, Olitski's work was included in numerous influential exhibitions of the decade, including Greenberg's Post Painterly Abstraction in 1964 and the Venice Biennale of 1966, among others. From 1963 to 1967 he taught at Bennington College where he became friendly with colleagues Anthony Caro and Kenneth Noland.

The abandonment of Color Field and a return to a gestural application of paint in Olitski's work of the 1970s was a harbinger of things to come. This trend continued through the succeeding decades and may even be seen in Olitski's vividly chromatic paintings of his last years. *Salome Rock* comes from a series of works during the late 1980s and 1990s in which the artist was using additives in acrylic paint to exploit not only the three-dimensional qualities of gesture, but also notions of hue and pigment that in many ways recall his Color Field paintings of the 1960s. Olitski synthesized techniques by applying thick acrylic paint with a glove, working it back and forth as if washing a window, and afterwards spraying pigment on top.[4] The effect of additives to the pigment can range from near monochromatic blacks and grays to a spectrum of seemingly infinite prismatic colors depending on the angle of illumination. —MNP

1. Jules Olitski, interview with John Walters, September 30, 2003; cited in Lauren Poster, ed., *Jules Olitski* (Marlboro, VT: Four Forty, 2005), 22.
2. Stuart Preston, "Three Generations of Moderns," *New York Times* 24 May 1959, 17.
3. Jules Olitski, "How My Art Gets Made," *Partisan Review* (Fall 2001): 618.
4. Darny Bannard, *Jules Olitski: New Paintings*, exh. cat. (Miami: The New Gallery, University of Miami, 1994), n.p.

PHILIP PAVIA

(1912–2005)

NA 2002

Freefall Black and White, 1994
Marble
$12^3/_4$ x 13 x $13^7/_8$ inches
NA diploma presentation, 2002
© Natalie Edgar

With a legacy as timeless as the stone he carved, Philip Pavia's lifetime affair with marble began as a child in Stratford, Connecticut. The son of an Italian stonecutter, Pavia attended Yale University for a short time before moving to New York City to study at the Art Students League, where he met Arshile Gorky and befriended Jackson Pollock. In 1934, the artist studied at the Accademia d'Arte in Florence, often visiting Paris. When he returned to New York in 1938, Pavia brought with him a passionate love of debate and sincere affection for artistic discourse. This enthusiasm inspired him to organize the Club in 1948, a series of gatherings of artists assembled in various locations under the pretext of artistic discussion. These vanguard meetings, which Pavia hosted until 1956, essentially served as a forum for most of the New York School, whose revolutionary ideas and strong personalities would define abstract art for nearly a generation.

Following his position as chief organizer of the Club, Pavia published the magazine *It Is* (1958–61), which served as the torchbearer for Abstract Expressionism. In 1961, he had his first solo exhibition of abstract sculpture at the Kootz Gallery in New York and in 1969 created *Monumental Marble Abstraction*, a ten-foot high work that now resides at the entrance to the Cloisters Museum in New York City. By working in stone, Pavia essentially practiced an ancient art in a modern, avant-garde style. As Pavia has stated: "The abstract painters . . . Pollock, de Kooning, Kline—inspired me . . . I saw marble under the skin of their planes."[1] Pavia's use of the labor intensive, direct carving method recorded the artist's subtractive strokes yet created works whose form suggested the origins of the world and the primeval anatomy of stone. Pavia also worked extensively in bronze and terra cotta, but, according to the artist, "marble throughout the centuries has had a unique quality: the state of mind of the artist hovers in its voids."[2]

Freefall Black and White is derived from a series of marble sculptures that Pavia began in the 1960s. Paring ascension with collapse, the sculpture cultivates forms from amputated blocks, while its crumbling structures suggest the weight of history and the ruins of ancient civilizations. Yet a paradox exists between the anarchic arrangement of stone and its high level of craftsmanship. Polished to the point of glistening perfection, the smooth surface contradicts the raw marble exposed by the artist's chisel. With a tranquility that conceals its defiant nature, *Freefall Black and White* displays a degree of freedom and intellectual vigor that pushes the work beyond the physical realm and into an interior space. It is as if the vibrations of Pavia's strokes shatter the stone's surface, revealing the truth of both the material and the artist harmonizing an inherently static traditional medium with modern Abstract Expressionism. —MS

1. Philip Pavia, "Stone Notes: Direct Carving," *Art News* 65 (May 1966): 63.
2. Philip Pavia, "Five States of Mind," *Art News* 68 (May 1969): 23.

DEBORAH REMINGTON

(b. 1935)

NA 1999

Velsuna II, 1973
Color lithograph on white Copperplate
 Deluxe paper
EDITION: 9/12
IMAGE SIZE: 27 15⁄16 x 21 1⁄4 inches
SHEET SIZE: 27 15⁄16 x 21 1⁄4 inches
NA diploma presentation, 1999
Art © Deborah Remington/Licensed by
 VAGA, New York, NY

Deborah Remington was at the center of the Beat movement in 1950s San Francisco. She was a co-founder of the Six Gallery, an artists' collective that soon became an important venue for Beat music, film, poetry, and art. Enrolling at the progressive California School of Fine Arts in 1949, she studied with Elmer Bischoff, NA, Ed Corbett, David Park, Hassell Smith, and Clyfford Still, graduating in 1955. She subsequently traveled in Southeast Asia and India, moving to New York in 1965, and also living for a short time in Paris. Remington had been partially influenced by the structural imagery in Franz Kline's paintings, and in the early 1960s while painting in a gestural, Abstract Expressionist style, her work was featured in solo exhibitions at the Dilexi Gallery in San Francisco.[1] By the late 1960s when she was exhibiting at the Bykert Gallery, New York, and Galerie Darthea Speyer, Paris, her style had shifted to precisely rendered, centralized forms. The artist's most recent work combines her emblematic, nested shapes of the 1960s and 70s with the Expressionist style and all-over compositions of her work from the 1980s.

Velsuna II is typical of the artist's imagery of the 1970s: a nearly symmetrical, shield-like form is centered against an empty background, while a central area of gray suggests a convex mirror or other reflective surface. A blue, wing-like shape within seems to reflect an object or creature flying off to the right. The uneven edges of the form and the rich texture of the ink prevent the motif from becoming too mechanical. The shapes in Remington's work have been compared to Japanese calligraphy, an appropriate comparison as the artist spent the year 1958-59 studying contemporary and traditional calligraphy in Japan. The form in *Velsuna II*, however, relates more closely to the shape of the inkstone used in preparing the ink for calligraphy. The word Velsuna refers to an ancient Etruscan city and was chosen by the artist for its lack of associations, while the dignified sound of the name she felt suited this image.[2]

Remington has described her work as dealing with "the paradoxes of visual perception.... The images are couched in paradoxical terms and must challenge the mind's eye, must invoke opposites and hold them in tension."[3] Here the color gradations evoke a mysterious kind of light: the background fades from dark at the top to light at the bottom, while the center shape paradoxically has a reversed gradation. These gradations were achieved through a complex printing process involving twelve colors and five runs through the press, a challenge Remington tackled with collaborating printer Richard Newlin.[4] The result is a print in which the motifs common in Remington's painted work are condensed into a simplified form that alludes to outside associations yet remains mysterious.

—CMB

1. Paul Schimmel and Dore Ashton, *Deborah Remington: A 20-Year Survey* (Newport Beach, CA: Newport Harbor Art Museum, 1983), 17.
2. Deborah Remington, conversation with author, January 18, 2007.
3. http://www.deborahremington.com/. Accessed January 19, 2007. This website provides a summary of the artist's career to date with images of her paintings, drawings, and prints and a personal statement.
4. *Velsuna II* is one of five color lithographs Remington editioned during a tenure at the Tamarind Institute of the University of New Mexico in 1973.

MILTON RESNICK

(1917–2004)

ANA 1980; NA 1989

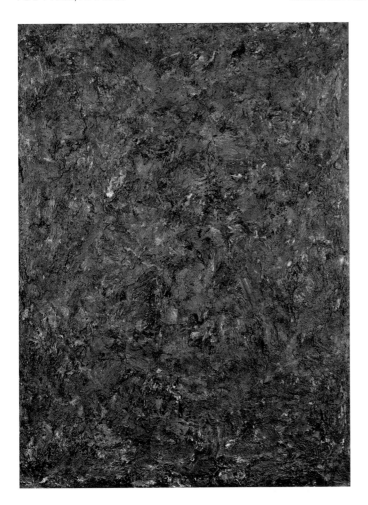

Straws 14, 1982
Oil on board
40 × 29 7/8 inches
ANA diploma presentation, 1987

While he never fully accepted the term Abstract Expressionist, Milton Resnick was part of the first generation of the New York School painters. Resnick was born in Bratslav, Ukraine and emigrated with his family to Brooklyn in 1922. He studied at Pratt Institute, Brooklyn, for one year before continuing his art education at the American Artists School. He also worked briefly on the WPA's Federal Art Project in the mural division as an assistant. Resnick served in the army from 1940 to 1945 and was stationed in Europe and Iceland. During this time he essentially stopped painting altogether until his return to the U.S. As a close friend of Willem de Kooning, NA elect, Resnick fell under his influence and his early canvases from the late 1940s recall the colorful biomorphic abstractions of the older artist. After returning from three years in Paris, however, Resnick began to find an individual voice in his painting. As early as 1957, he was known for dense applications of paint that created an encrusted impastoed effect.[1]

While he had been a founding member of the Club and an exhibitor in the seminal 1951 Ninth Street show, by the early 1960s, Resnick had not achieved the notoriety of some of his contemporaries from the New York School. At that time the general aesthetic tenor was beginning to shift away from the expressiveness of Abstract Expressionism and toward a simplified language that would become Minimalism. Resnick's paintings, however, became much more heavily encrusted with paint and his work took a decidedly monochromatic turn about this time, laying the foundation for his paintings of the succeeding decades.[2] The critical reception to Resnick's new style was tepid, but as one critic noted, not without merit, "many of the new paintings looks flatly uninteresting from a distance and you have to put your nose into them to get the reward of textural richness and density."[3]

By the mid-1960s Resnick's work had become almost entirely monochromatic and encrusted with thick daubs of layered paint, a tendency that continued through the 1980s. *Straws 14* comes from a series of paintings completed during this decade that were an outgrowth of an earlier series Resnick began in the late 1970s, known as the *Elephant* series. The artist found himself in conversation with subsequent paintings and insisted that they told him that he was merely a straw in the wind, which ultimately led to the title of the series.[4] Like other works in the *Straws* series, *Straws 14* is a seemingly infinite field of dark green that is deceptively colorful and interspersed with flecks of yellow, red, and brown. Works from this period have been identified as the extreme culmination of the overall effect sought after by members of the New York School.[5] —MNP

1. Dore Ashton, "Resnick's Abstracts Suggest a Free Space," *New York Times* 15 March 1957, 18.
2. Linda Cathcart, *Milton Resnick: Paintings, 1945–1985*, exh. cat. (Houston, TX: Contemporary Arts Museum, 1985), 9.
3. Brian O'Doherty, "His First Show at the Wise is His First Since '61," *New York Times* 8 February 1964, 20.
4. The *Elephant* series was arbitrarily given its titled by Resnick's wife, painter Pat Passlof, NA elect. Cathcart, *Milton Resnick*, 12.
5. Roberta Smith, "From Milton Resnick, Dense Fields of Paint," *New York Times* 3 June 1988, C25.

DOROTHEA ROCKBURNE

(b. 1932)

NA 2002

Locus Series, 1972
Six etchings and aquatints with oil paint and graphite on white
 Strathmore rag paper
EDITION: 7/42
IMAGE SIZE: 40 × 30 inches each
SHEET SIZE: 40 × 30 inches each
NA diploma presentation, 2004
© Dorothea Rockburne/Artists Rights Society (ARS), New York

The work of Dorothea Rockburne defies categorization. It has been called Minimalist, post-Minimalist, and Conceptual, but ultimately it transcends the inherent constraints imposed upon it by these classifications. Rockburne was born in Montreal, Canada and followed a traditional art curriculum at the Ecole des Beaux-Arts, Montreal and the Montreal Museum of Fine Arts School, where she learned painting, sculpture, printmaking, and life drawing. At the age of eighteen, she enrolled in the experimental Black Mountain College where she studied painting with Franz Kline, Esteban Vicente, NA, Philip Guston, ANA elect and drawing with Jack Tworkov. Black Mountain was rigorously interdisciplinary and Rockburne's course of study also included music with John Cage, dance with Merce Cunningham, and mathematics with Max Dehn. The entire experience would have a forceful and lasting impact on her future work, in particular Dehn's ideas on topology, surface mapping, and set theory.[1]

By the mid-1950s Rockburne was living in New York and first showed at the E.A.T. (Experiments in Art and Technology) exhibition at Leo Castelli Gallery in 1966 that included Larry Rivers, NA, Lee Bontecou, NA elect, Cy Twombly, NA elect, Andy Warhol, Robert Rauschenberg, NA, and many others. In the late 1960s the artist was creating large multipaneled paintings on metal, often using a wrinkle-finish paint. Toward the end of the decade, however, Rockburne's interest in mathematical concepts led her to incorporate ideas of set theory and the golden section into her work, not as a subject, but more as a creative tool.[2] These elements were used to create her seminal series, *Drawing Which Makes Itself*

(1972), which was first installed at the Whitney Museum's American Drawings exhibition in 1973. The series involved the notions of the self (through its reflexive nature), displacement, exceeding external limits, and creating a continuous surface, and served as an important precedent for later works.[3] Rockburne's desire to incorporate a continuous surface into a larger dynamic, or cosmic, view led to the creation of the *Locus Series*.[4]

Locus Series is inherently topological and the folds of the prints function in a similar capacity to drawn lines. The series is intended to be shown as one entire work in six sections. The circular rhythm of the spine creates a 180-degree concentric motion through the group, indicating a continuous surface, and thereby creating the "locus." The prints recall not only the artist's drawings, but also contain an element of inherent corporeality. Drawing and working on paper have always been essential to Rockburne's work. Her understanding of drawings has been partly based on childhood experiences of skiing through fresh snow and responding to the brightness of the line and its location within the larger topology.[5] *Locus Series* was created by folding the paper, inking portions of it with an oil-based ink, and printing them in their folded state. The oil paint was then polished after printing, creating an extremely subtle and nuanced surface.[6] For the artist, folding paper is a physical way to experience algebra and other mathematical concepts, and this series is an important achievement in the artist's oeuvre combining her systemic approach with drawing and mathematics.[7]

—MNP

1. Anna Lovatt, "Seriality and Systemic Thought in Drawing c. 1966–1976: Ruth Vollmer, Sol Lewitt, Eva Hesse, Mel Bochner and Dorothea Rockburne" (PhD diss., Courtauld Institute of Art, University of London, 2006), 166. At its most basic, set theory is the mathematical study of the properties and relations of sets.
2. Michael Marlais, *Dorothea Rockburne, Drawings: Structure and Curve*, exh. cat. (New York: John Weber, 1978), 4. The golden section, which dates to antiquity, is a mathematical ratio in which a segment is divided into two unequal parts; the ratio of the smaller portion to the larger portion is equal to the ratio of the larger portion to the whole.
3. Dorothea Rockburne, conversation with Klaus Kertess, December 10, 2002, National Academy Museum Archive. Also see Marcia Tucker, *Early Work by Five Contemporary Artists: Ron Gorchov, Elizabeth Murray, Denis Oppenheim, Dorothea Rockburne, Joel Shapiro* (New York: The New Museum, 1977), n.p. Later series that incorporate these ideas include the *Robe Series* (1974), the *Copal Series* (1976), the *Roman Series* (1977–78), the *Vellum Curve Series* (1978), and the *Arena Series* (1978). Marlais, *Dorothea Rockburne, Drawings*, 3.
4. Dorothea Rockburne, email correspondence with author, March 3, 2007.
5. Lovatt, "Seriality and Systemic Thought in Drawing c. 1966–1976...," 175.
6. The series was produced by Kathan Brown at Crown Point Press and published by Parasol Press.
7. Dorothea Rockburne, telephone interview with author, December 7, 2006.

MARION ROLLER

(b. 1924)

ANA 1994; NA 1994

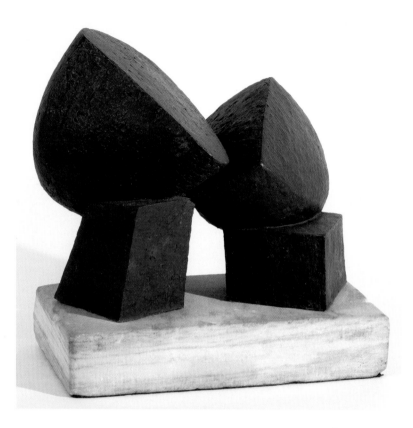

Empathy, ca. 1995
Terra cotta, 10 × 10 × 8 inches
NA diploma presentation, 1995
© Marion Roller

Working in bronze and terra cotta, Marion Roller creates sculpture that speaks to the human spirit. Born in Boston, Roller initially studied art at the Vesper George School of Art from 1943 to 1945. She continued her studies at the Art Students League, New York, where she learned traditional sculpting techniques based on modeling from the human figure. It was at Greenwich House Pottery in New York, however, an institution founded in 1909 to continue the tradition of pottery, where Roller first worked with terra cotta. There she studied for five years under the direction of figurative sculptor Lu Duble, NA, who inspired Roller to go beyond mere imitation in her work and to strive for genuine originality.[1] In the 1970s Roller returned to school and received her BA from Queens College in 1974. For the remaining part of the decade she taught in the sculpture department at the Fashion Institute of Technology and also at the Sculpture Center. She later headed the Design Department of the Traphagen School of Fashion, New York, where she was responsible for establishing the sculpture curriculum.

Roller is a sculptor who is not limited by scale and has created both diminutive and monumental works. While she has been a prolific medallic sculptor, she is perhaps best known for her large public commissions. These include a number of figurative projects for the Nassau Center for Emotionally Disturbed Children and St. Mary's Children and Family Services, Syosset, New York, among others. Roller has participated in exhibitions throughout the U.S. and in Europe and has also worked as a writer and reviewer for *Sculpture Review* magazine.[2] She has exhibited regularly in the Academy's Annuals since 1977 and in 2000 she was commissioned to create the National Academy's Lifetime Achievement Award medal.

Empathy is composed of two black terra cotta geometric forms that rest on a small white plinth base. After witnessing the tender embrace of a couple, the artist was inspired to create the piece as a work of two representational heads. Over time, she repeatedly simplified the forms until they became abstract geometric elements. While *Empathy* is devoid of overt representation, it has strong corporeal associations that recall an intimate physical and psychological connection between two people. It is intended to serve as a visual metaphor for an emotion and not a literal representation.[3] Roller has stated that "For me sculpture is the embodiment of an idea, a thought that I hope to communicate to the viewer. I want it to be a metaphor, something more than just the physical sculpture itself."[4] —MNP

1. Marion Roller, conversation with author, April 20, 2007.
2. Jonathan Fairbanks and Frederick Hart, *Contemporary Sculpture at Chesterwood*, exh. cat. (Stockbridge, MA: National Trust for Historic Preservation, 1997), 32.
3. Marion Roller, telephone conversation with author, April 10, 2007.
4. Marion Roller, "Entry Form: 174th Annual Catalogue Information," National Academy Museum Archive.

TONY ROSENTHAL

(b. 1914)

ANA 1992; NA 1994

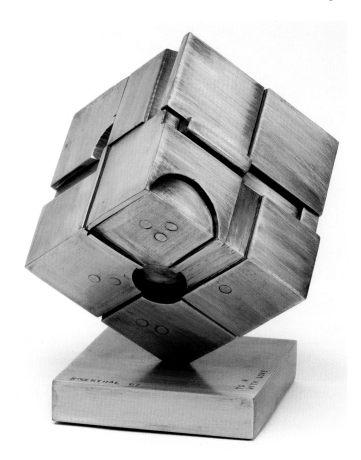

Alamo, 1967
Hand cut and welded brass and bronze
9 1/2 x 8 x 8 inches
ANA diploma presentation, gift of Tony
 Rosenthal, 1996
Art © Tony Rosenthal/Licensed by VAGA,
 New York, NY

Known primarily for his large public sculptures, Bernard (Tony) Rosenthal was born in Highland Park, Illinois and as a young man attended evening and Saturday sculpture classes at the Art Institute of Chicago. He enrolled in the University of Michigan and following graduation returned to Chicago to work with the Russian sculptor Alexander Archipenko, continuing his studies soon thereafter at the Cranbrook Academy of Art. Initially Rosenthal worked in a figurative mode and showed his first public sculpture, *Nubian Slave*, at the 1939 World's Fair in New York as part of the Elgin Watch Company's building. During World War II, Rosenthal served as the commander of a unit of artists working on topographical models. He was stationed in England and it was there that he first saw the influential work of British sculptor Henry Moore.

Rosenthal returned to Chicago in 1946 and over the following decade his work became increasingly abstract. He won a number of important public commissions, including wall reliefs for General Petroleum's headquarters in 1949 and IBM's western headquarters in 1958. During this time, and throughout the early 1960s, the artist's welded metal sculpture was exhibiting the expressive characteristics of the concurrent Abstract Expressionist movement. By the middle of the decade, however, he had returned to his earlier constructivist roots and adopted the vocabulary of cool reserve and primary structures of Minimalism. Geometry would provide the underlying structure for much of his subsequent work, including additional public commissions and most notably his controversial work *Alamo* of 1966. The calligraphic nature of Rosenthal's work from the late 1970s (and continuing through the last decade), recalls the gestural inclinations of his expressionistic sculpture of the 1950s, albeit in a much different way.[1]

Alamo was one of 32 public sculptures installed around New York City in 1967 as part of an outdoor exhibition, Sculpture in Environment, and was located on the traffic island at Astor Place in front of The Cooper Union, where it remains today.[2] Organized by the New York City Department of Parks, the exhibition included work by Alexander Leiberman, George Rickey, NA elect, Tony Smith, David Smith, and others and elicited a range of opinions. Perhaps the most controversial work in the show was Rosenthal's *Alamo*. The sculptures were intended to be temporary, with the works removed from public view after a couple weeks. However, an anonymous donor gifted *Alamo* to the City so that it could remain in place.[3] Rosenthal has completed numerous additional works that have been based on a similar composition to *Alamo* including *Endover* (1968; University of Michigan), *Cube '72* (1972; Guild Hall, East Hampton), and *Marty's Cube* (1983; Collection Martin Z. Marguiles). This maquette differs from the full scale piece in that it is constructed out of polished brass and bronze, materials that lend a more precious and less severe aspect to the work than the completed sculpture in black painted Cor-Ten steel. —MNP

1. Edward Albee and Sam Hunter, *Tony Rosenthal* (New York: Rizzoli, 1999). 7.
2. Edwin Bolwell, "Sculpture on the City's Sidewalks Sparks Interest and Irreverence," *New York Times* 26 September 1967, 1.
3. "Astor Cube Will Stay In Place," *New York Times* 23 November 1967, 33.

PAUL RUSSOTTO

(b. 1944)

ANA Elect 1993; NA 1994

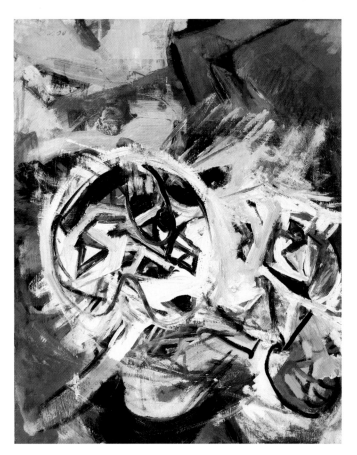

The Broken Mirror, 1982
Oil on canvas
20 × 16 inches
Gift of Paul Resika, 1998
© 1982 Paul Russotto

As a direct artistic descendant of the New York School painters, Paul Russotto's work fits squarely into the lineage of post-war American abstract painting. Born in New York, Russotto was a student in the early 1960s, at a moment when the pervasive dominance of Abstract Expressionism had waned considerably, and many artists were exploring alternatives to gesture-based abstract painting. He enrolled at the Art Students League and followed a traditional art curriculum based on figurative representation under Frank Mason and Raymond Breinin, studying there for less than one year. Russotto's true education however, was conducted, as he described it, "on the road," as he met and became close with many artists of the Abstract Expressionist generation such as James Brooks, NA elect, and Esteban Vicente, NA.[1] Nevertheless, Russotto was working in a representational style and in 1967 he exhibited *Still Life with Apples and Eggs* in the National Academy's Annual. Throughout the 1970s his work continued to be representational, but would take a dramatic turn in the coming decade.

In 1980 Russotto began to work on a series of abstract collages exclusively in black and white. He was grappling with his own understanding of color and in an attempt to allay this problem, he eliminated it entirely from his work.[2] As one writer observed, "Denial of color served as a right of passage [for the artist]; at the same time, a long meditation on color itself."[3] Russotto also began exploring automatic techniques of drawing and painting in the manner of the Surrealists. The works that emerged from this period were, not surprisingly, predominantly abstract and sometimes referential, but all were characterized by a strongly improvisational feel.[4] By 1982, the artist had returned to working with color and continued to pursue automatic techniques. Russotto is very much interested with the notion of mark making on a fundamental level and how it operates within the larger context of a universal abstract language. His interest includes Prehistoric painting, and he has identified an abstract vocabulary of three basic types of marks: a point, a line, and a mass.

While some of his work from the 1980s shows similarities to the concurrent Neo-Expressionist movement, it is essentially antithetical to it. One of Russotto's primary aims is to eliminate the premeditated composition and rid himself of the conscious mind during the creative process. *Broken Mirror* dates from the period of the artist's career when he reintroduced color into his painting. The ground is punctuated with areas of blue and red overlaid with frenetic gestural brushstrokes of white, highlighted with black within a circular motif in the central portion of the painting. The artist's interest in Prehistoric mark making is evident in *Broken Mirror* and he has incorporated the three basic types of marks. These are the elements of his abstract vocabulary, and, as he noted, "In many ways, it seems to me, nothing much has changed since the beginning of time. I guess you can say that I represent the return to the original necessity of art."[5] —MNP

1. Paul Russotto, telephone conversation with author, March 31, 2007.
2. Ibid.
3. Alan Jones, *Paul Russotto: Paintings*, exh. cat. (New York: Kouros Gallery, 1995), 3.
4. Eleanor Hartney, *Paul Russotto: Paintings*, exh. cat. (New York: Kouros Gallery, 1993), 3.
5. Cited in Jones, *Paul Russotto: Paintings*, 23.

REUBEN TAM

(1916–1991)

ANA 1975; NA 1987

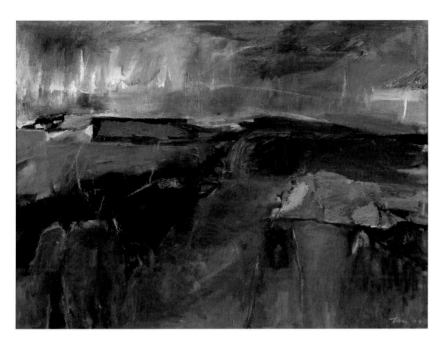

Monhegan Night, 1956
Oil on canvas
34 x 46 inches
Gift of the artist's estate, 1991
© Geraldine King Tam

One of the more consistently referential abstract artists, Reuben Tam was born in Kauai, Hawaii and enrolled at the University of Hawaii before continuing his studies at the California School of Fine Arts in 1940. That same year Tam was awarded the First National Prize at the Golden Gate International Exposition for his painting *Koto Crater*. Soon thereafter he moved to New York where he pursued graduate studies in art history, philosophy, and psychology at Columbia University and the New School for Social Research.[1] Tam began teaching painting at the Brooklyn Museum Art School and was a prolific exhibitor in New York City and throughout the country. He would also later hold teaching positions at Queens College and Oregon State University. He first showed with the Downtown Gallery beginning in 1945 and his landscape-inflected abstractions led a critic to presciently write that anyone "Who looks for anything like concrete transcriptions [in Tam's work] is lost. I have a feeling that in time Rueben Tam will make abstract images sharper, more explicit than those now assembled at the Downtown Gallery."[2]

In 1948 Tam won a Guggenheim Fellowship, and by the 1950s his painting had grown increasingly abstract. Around this time Tam and his wife began to spend summers on Monhegan Island, Maine and would continue to do so for more than thirty years. He was deeply affected by the landscape, particularly the rugged coasts of his native Hawaii and his adopted summer home of Monhegan. Throughout his life he was also a prolific poet who earned distinction late in life, winning the Elliot Cades Literary Award in 1989. In 1996, a volume of his poetry was published by the University of Hawaii Press.[3] All of Tam's work is imbued with an essence of location and this has led him to write: "For most all of my life as an artist, the one overwhelming factor had been my pursuit of the spirit of place. My work in painting is inseparable from the sources of its subject matter."[4]

Monhegan Night was painted during a period of Tam's career when he was working most closely to pure abstraction. The work shows frenetic gestures of Abstract Expressionism within a narrow swath of tonal values in blues and grays that give the painting its enigmatic monochromaticism. Indeed, were it not for the instructive title, the work could be considered entirely absent of representation. Tam first exhibited in the National Academy's annual exhibition of 1947. After the 1950s he continued to draw on the inspiration of the landscape and his work became increasingly representational. In 1980 he returned permanently to Kauai, Hawaii. As noted in the press release following his death, Tam's work continued to be "expressive and invariably moving, with an inner spirituality that communicates itself to the viewer."[5] —MNP

1. *Early and Recent Landscapes by Reuben Tam*, exh. cat. (Kauai, HI: Kauai Museum, 1987), n.p.
2. Edward Alden Jewell, "A 'Modern' Annual, Philadelphia Event Take On a Strong Contemporary Tone—Local Shows," *New York Times* 28 January 1945, 8.
3. Reuben Tam, *The Wind-Honed Islands Rise: Selected Poems of Reuben Tam* (Honolulu: University of Hawaii Press, 1996).
4. James Jesnsen and Geraldine King Tam, *Paintings by Reuben Tam*, exh. cat. (Honolulu, HI: The Contemporary Museum, 1991), n.p.
5. Press Release, January 7, 1991, National Academy Museum Archive.

ESTEBAN VICENTE

(1903–2001)

ANA 1980; NA 1985

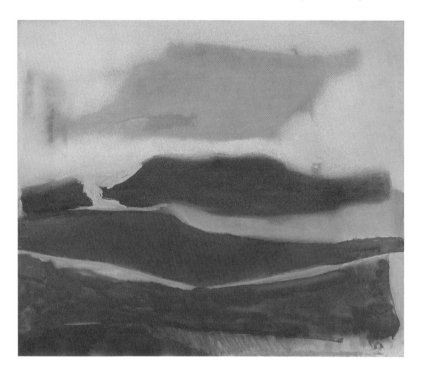

Untitled, 1985
Oil on canvas
42 x 50 inches
NA diploma presentation, 1986
© Estate of Estaben Vicente

Esteban Vicente was the only Spaniard of the first-generation New York School painters. Born in Turegano, Spain, the artist grew-up in the shadow of Madrid's famous Prado Museum. He studied sculpture for three years at the San Fernando Royal Academy of Fine Arts in Madrid, where he met the Surrealist painter Salvador Dalí. After graduating he abandoned the chisel for the brush, stating that: "with painting, the thing that happens between me and the material happened right away. Especially with color." [1] The artist had his first one-man show in Madrid in 1928 and a year later left for Paris, where he met such influential figures as Picasso and Max Ernst. After the start of the Spanish Civil War in 1936, Vicente moved to New York, and his art entered a new phase of expression.

In 1937, Vicente had his first American exhibition at the Kleeman Gallery in New York, but afterwards agreed to serve in Philadelphia as the vice consul for the Republic of Spain until the end of the Spanish Civil War in 1939. During the following decade, Vicente became an American citizen and spent much of his time experimenting with various artistic styles while teaching Spanish at the Dalton School in New York. In 1950, Vicente emerged as one of the premiere abstract artists in New York when his work was chosen by Clement Greenberg and Meyer Schapiro to be included in the seminal exhibition of Abstract Expressionism, New Talent 1950. Vicente's style continued to evolve; in the 1960s, large, ethereal shapes materialized in his paintings, and in the 1970s he experimented with a spray gun to create edgeless entities of delicate layers. By the 1980s, after a lifetime of stylistic development, Vicente reintroduced the brushstroke and began to explore the relationship between drawing and color with an exuberance that translated onto his canvases.

Rather than adhering to the psychic automatism of Abstract Expressionism, Vicente relied on a more personal, creative process, stating that, "Intuition is what is important." [2] *Untitled* is rooted in his intuitive, experimental excitement that laps onto the canvas in gentle waves of color. While the sumptuous orchestration of color conveys an emotive arrangement, his brushwork punctuates the tonal fields with the artist's personal touch. *Untitled* displays an ethereal elegance whose technical execution echoes the color fields of Mark Rothko and Helen Frankenthaler, NA. The luminescent color and alternating warm and cool hues emerge and retreat into an ambiguous landscape. The tonal changes elicit a temporal, narrative element, suggesting the passing of the sun and time across the canvas of one's life. Vicente once said, "I'm looking all the time to express something that comes from inside." [3] *Untitled* hangs as a testament to a creative process that matured over nearly the entire history of art of the twentieth century. —MS

1. Elizabeth Frank, "Esteban Vicente: Child of the Century," *Art News* 92 (February 1993): 91–92.
2. Phyllis Braff, "Madrid Museum Gives Bridgehamptonite a Room of His Own," *New York Times* 21 March 1999, 621.
3. Carol Strickland "For Vicente, at 89, 'No End' to Maturing," *New York Times* 26 April 1992, LI, 15.

ISAAC WITKIN

(1936–2006)

ANA 1994; NA 1994

Study for Eolith, 1993
Bronze, ed. 1/3
32 × 25 × 8 inches
NA diploma presentation, 1996
© 1994 Nadine Witkin, Estate of Isaac Witkin

Born in Johannesburg, South Africa, Isaac Witkin reluctantly apprenticed with an academic sculptor as a young man only at the urging of his mother. He soon took to it, however, and in 1956 traveled to England to continue his art education, enrolling in Saint Martins School of Art the following year. It was an auspicious time for British sculpture, and Witkin's primary instructor was Anthony Caro, while his fellow students included Barry Flanagan, Philip King, and William Tucker, among others. Between 1961 and 1963, following his graduation from Saint Martins, Witkin worked as assistant to Henry Moore, who, as Witkin put it, would turn out "to be the missing link in my education."[1] Witkin and his contemporaries were experimenting at the time with materials such as fiberglass, aluminum tubing, glass, and plywood, creating polychrome works of high formalist simplicity and elegance. Witkin had his first solo exhibition in 1963 at Rowan Gallery and was included in the seminal exhibitions The New Generation: 1965 at Whitechapel Gallery, London, and Primary Structures: Young American and British Sculptors at the Jewish Museum, New York in 1966.

In 1965, Witkin was hired to replace Caro as the sculpture professor at Bennington College, where he would remain until 1979. During the early 1970s, the artist's work took a constructivist turn as he began to weld large geometric pieces of steel, creating complex angular sculptures. In 1978, however, he received a residency at the Johnson Atelier in New Jersey where he considerably expanded his knowledge of bronze casting by learning hollow casting and direct pouring techniques.[2] It was a breakthrough for the artist, after which time he began to work almost exclusively in bronze. Throughout the 1980s Witkin's work became increasingly lyrical in approach, often with references to nature facilitated by various casting methods. By the early 1990s, the sculptor often combined this lyricism with more volumetric shapes and incorporating planar elements with extruded forms.

Eolith is the study for the first of only a few stone sculptures Witkin would realize. It was commissioned by collectors Philip and Muriel Berman and first exhibited in 1995 at the outdoor sculpture park Grounds For Sculpture in New Jersey. In many ways, *Eolith* looks back to Witkin's early cast bronze works of the 1980s through its spatial arrangement and substantial mass and form. The work is inherently corporeal, and its tapered composition evokes an emergence from some primordial source. His stone works have been suggested as figure-like metaphors, intimating limbs or a torso.[3] While not a literal representation, the work's title refers to a crude stone tool or artifact. This study in bronze allowed Witkin to work out compositional problems and also served a practical purpose of logistical planning before commencing the final work. The finished version of *Eolith* was realized in Blue Mountain granite at a height of fourteen feet. —MNP

1. Cited in Karen Wilkin, *Isaac Witkin* (New York: Hudson Hills Press, 1998), 17.
2. Fred B. Adelson, "Welding Worlds Together," *New York Times* 15 November 1998, NJ4.
3. Wilkin, *Isaac Witkin*, 87.

JOSEPH ZIRKER

(b. 1924)

ANA 1992; NA 1994

Untitled, 1991
Monotype on white Arches 88 paper
IMAGE SIZE: 53⅝ × 35⅜ inches
SHEET SIZE: 60 × 41¾ inches
ANA diploma presentation, 1992
© 1991 Joseph Zirker

Since the late 1960s Joseph Zirker has developed innovative methods of monotype printmaking, his primary medium. Zirker grew up in rural Merced, California, where his introduction to art was through his father's sign shop. Initially enrolling to study art at University of California, Los Angeles, Zirker's education was interrupted by his service in the armed forces during World War II. Following the war, he resumed his education, first at UCLA and eventually at the University of Denver, graduating with a BFA in 1949. Zirker returned to Los Angeles to pursue graduate studies in printmaking at the University of Southern California under Jules Heller, who would be an enormous influence on him. He completed his MFA in 1951 and between 1961 and 1963 Zirker was a print and research fellow at the Tamarind Lithography workshop in Los Angeles. It was not until the late 1960s, however, that the monotype method of printmaking began to make a true impact on him. The 1968 exhibition of Degas's monotypes at the Fogg Art Museum was a revelation, and by the following year he was experimenting with monotypes using inks of varying viscosity to create color and textural effects.[1]

For most of the 1970s his imagery was representational and based on the human figure.[2] This was followed by stylistic and technical breakthroughs in 1977 as he eliminated representational imagery and began to introduce various mixed media elements into his prints, creating works that blurred the lines between sculpture, painting, and printmaking. These assemblages included fabric, twine, thread, and pieces of other prints added into the fibers of the supporting paper.[3] Over the next twenty years, Zirker continued to explore the possibilities of monotypes using different materials and methods until, in 1999, he realized that dry acrylic paint could be removed from a support intact, effectively creating a cast monotype. It is this method that the artist has continued to refine and one that is detailed in his instructional publication *The Cast Acrylic Print* (2002).[4]

Untitled comes from a series of monotypes that Zirker created in the early 1990s. Like many of the works from that period it is large in scale and is compositionally similar to others from the group. While the term *monotype* implies a singular impression, Zirker is often able to create variations on an image with residual ink left on the plate after printing by adding additional ink and further manipulating it. *Untitled* combines geometric and gestural elements anchored by the central column containing two ovals arranged vertically. The bottom oval is a spiral, an activating signal for Zirker and as he interprets it, "a path of ever widening or diminishing relationship to its center. The spiral is coiled to both store and release energy. I feel it as internal and personal, emerging and submerging in process of becoming and in process of dissolving in planes of shifting moods of dark and light, in densities and transparencies."[5] These geometric details are reconciled with a vast gestural background of ethereal and fluid wash.

—MNP

1. Joseph Zirker, "Innovations in Monotype and Paper Art," *Arte Grafika* 6 (April–June, 1990): 22.
2. Tonia Macneil, "Master of After-Dinner Diversions," *Palo Alto Weekly* 22 September 1982, 27.
3. Zirker, "Innovations in Monotype and Paper Art," 24.
4. Joseph Zirker, *The Cast Acrylic Print: A New Approach in the Making of Monotypes and Intaglio Prints without Pressure* (Philadelphia: Xlibris Corporation, 2002), 2–3.
5. Joseph Zirker, transcript of a taped statement for an exhibition at Smith Andersen Gallery, September 1991, p. 2, National Academy Museum Archive.

Exhibition Checklist

Clinton Adams (1918–2002)
ANA 1991; NA 1992
Triad VI, 1980
Color lithograph on off-white German
 etching paper
EDITION: 12/12
IMAGE SIZE: 27 3/8 x 19 5/8 inches
SHEET SIZE: 29 1/2 x 21 7/16 inches
NA diploma presentation, 1992

Pat Adams (b. 1928)
ANA 1992; NA 1993
Des Clefs, 1990
Mixed media on paper mounted to canvas
15 1/8 x 20 1/4 inches
ANA diploma presentation, 1992

Stephen Antonakos (b. 1926)
NA 2004
The Light, 1997
White Varathene paint on wood with
 neon
24 x 25 3/8 x 4 1/2 inches
NA diploma presentation, 2005

Richard Anuszkiewicz (b. 1930)
ANA 1992; NA 1994
Temple of Deep Crimson, 1985
Acrylic on canvas
60 x 48 inches
NA diploma presentation, 1995

Will Barnet (b. 1911)
ANA 1974; NA 1982
Joyous, 2006
Oil on canvas

32 1/2 x 24 1/2 inches
Courtesy Babcock Galleries

Elmer Bischoff (1916–1991)
ANA 1973; NA 1985
#35, 1978
Acrylic on canvas
85 x 80 1/8 inches
NA diploma presentation, 1986

Robert Blackburn (1920–2003)
ANA 1981; NA 1994
Modern Times, 1984
Color woodcut on white Japanese paper
EDITION: Unknown
IMAGE SIZE: 11 1/4 x 11 5/16 inches
SHEET SIZE: 21 15/16 x 16 inches
ANA diploma presentation, 1998

James Bohary (b. 1940)
ANA 1992; NA 1994
Dinner Plate, 1989
Retouched monotype with acrylic and oil
 pastel on paper
21 1/4 x 16 1/2 inches
Gift of the artist, 2004

James Brooks (1906–1992)
ANA 1980; NA Elect 1985
Kardom, 1981
Acrylic on canvas
32 x 36 inches
ANA diploma presentation, 1984

Bernard Brussel-Smith (1914–1989)
ANA 1952; NA 1972

Cain and Abel, ca. 1957
Engraving and soft gound etching on cream
 wove paper
EDITION: Artist's proof
IMAGE SIZE: 19 5/16 x 11 7/8 inches
SHEET SIZE: 24 5/8 x 17 3/16 inches
NA diploma presentation, 1973

Nicolas Carone (b. 1917)
NA 2001
Summer Tryst, 1985
Oil on wood panel
20 x 30 1/8 inches
NA diploma presentation, 2004

Edmond Casarella (1920–1996)
ANA 1993; NA 1994
Tree Burst, 1958
Color paper relief print on beige laid paper
EDITION: 14/18
IMAGE SIZE: 30 1/16 x 21 7/8 inches
SHEET SIZE: 31 x 22 9/16 inches
NA diploma presentation, 1994

William Crovello (b. 1929)
NA 2002
Granite Drawing (OK Bonito), 1985
Red granite
16 x 16 x 15 1/2 inches
NA diploma presentation, gift of Brigitte
 and William Crovello, 2003

Edward Dugmore (1915–1996)
ANA 1992; NA 1994
Opus 130-B, 1987
Oil on canvas

48 x 38 inches
ANA diploma presentation, 1993

Nick Edmonds (b. 1937)
ANA 1992; NA 1994
Icicles, 1982
Walnut wood and fieldstone
36 x 30 x 18 inches
ANA diploma presentation, 1993

Lin Emery (b. 1928)
NA 1999
MITRE, 2001
Aluminum and stainless steel bearings
26 x 16 x 16 inches
NA diploma presentation, 2003

Lawrence Fane (b. 1933)
NA 2002
Monument, 1996
Poplar wood
68 x 50 x 24 inches
NA diploma presentation, 2003

Andrew Forge(1923–2002)
ANA 1992; NA 1994
Fragment. Roman Torso, 1985–86
Oil on canvas
44$\frac{3}{8}$ x 36$\frac{1}{4}$ inches
NA diploma presentation, 1993

Helen Frankenthaler (b. 1928)
ANA 1985; NA 1994
Causeway, 2001
Color spit-bite aquatint with soft ground
 on cream wove paper
EDITION: Artist's proof, 14/24
IMAGE SIZE: 21$\frac{9}{16}$ x 31$\frac{9}{16}$ inches
SHEET SIZE: 28$\frac{1}{2}$ x 37$\frac{3}{4}$ inches
NA diploma presentation, 2002

Sonia Gechtoff (b. 1926)
ANA 1993; NA 1994
The Visitor, 1960–61
Oil on canvas
32 x 32 inches
Gift of the artist, 2006

Robert Goodnough
ANA 1992; NA 1994
Battle One, 1992

Oil on canvas
18 x 34 inches
ANA diploma presentation, 1993

Stephen Greene (1917–1999)
ANA 1980; NA 1982
Night, 1982
Oil on canvas
30$\frac{1}{8}$ x 30$\frac{1}{8}$ inches
NA diploma presentation, 1983

Richard Haas (b. 1936)
ANA 1993; NA 1994
Blue Bursts In, 1966
Color woodcut on paper
EDITION: Artist's proof
IMAGE SIZE: 23$\frac{7}{8}$ x 17$\frac{3}{4}$ inches
SHEET SIZE: 29$\frac{1}{4}$ x 24$\frac{1}{2}$ inches
Gift of the artist, 2007

Richard Hunt (b. 1935)
NA 1999
Offset, 2002
Stainless steel
38 x 28 x 24 inches
NA diploma presentation, 2002

Angelo Ippolito (1922–2001)
NA 2001
Roundabout, 1982
Oil on linen
66$\frac{1}{4}$ x 58$\frac{5}{8}$ inches
NA diploma presentation; gift of Michael
 and Jon Ippolito, 2006

Jasper Johns (b. 1930)
ANA 1990; NA 1994
Green Angel, 1991
Color etching on Barcham Green Boxley
 paper
EDITION: 11/46
IMAGE SIZE: 25$\frac{1}{2}$ x 18$\frac{1}{16}$ inches
SHEET SIZE: 31$\frac{3}{16}$ x 22$\frac{11}{16}$ inches
NA diploma presentation, 1997

Wolf Kahn (b. 1927)
ANA 1979; NA 1980
Sienese Countryside, 1963
Oil on canvas
27$\frac{1}{2}$ x 39$\frac{1}{2}$ inches
Gift of the artist, 2006

James Kelly (1913–2003)
NA 1995
Hurly-Burly, 1991
Oil on canvas
40 x 30 inches
NA diploma presentation, 1996

Gyorgy Kepes (1906–2001)
ANA 1973; NA 1978
Native Fragments, 1972
Oil and sand on canvas
50$\frac{1}{4}$ x 40 inches
NA diploma presentation, 1979

Karen Kunc (b. 1952)
ANA 1993; NA 1994
Broken Code, 1999
Color woodcut on cream laid paper
EDITION: 8/20
IMAGE SIZE: 42 x 23$\frac{15}{16}$ inches
SHEET SIZE: 42 x 23$\frac{15}{16}$ inches
Gift of the artist, 2004

Vincent Longo (b. 1923)
NA 1997
Untitled, 1995
Acrylic on wood panel
35$\frac{1}{8}$ x 32 inches
NA diploma presentation, 1998

Robert Mangold (b. 1937)
NA 2004
Frieze Study I, 1994
Graphite on two sheets of paper
22$\frac{3}{4}$ x 30 inches each sheet
NA diploma presentation, 2005

Leo Manso (1914–1993)
ANA 1979; NA 1981
Kerouan I, 1977
Acrylic on canvas
49$\frac{7}{8}$ x 39$\frac{7}{8}$ inches
NA diploma presentation, 1984

Emily Mason (b. 1932)
NA 1999
For a Moment, 1996
Oil on canvas
24 x 24 inches
NA diploma presentation, 2002

Robert Motherwell (1915–1991)
ANA 1990
Automatism Elegy (State I White), 1980
Lithograph on white Arches Coverpaper
EDITION: 40; Artist's proof III / VIII
PLATE SIZE: 4 11/16 x 9 15/16 inches
SHEET SIZE: 17 13/16 x 22 1/16 inches
ANA diploma presentation as a
 posthumous gift of the Dedalus
 Foundation, Inc., 1996

Jules Oltiski (1922–2007)
ANA 1992; NA 1994
Salome Rock, 1990
Acrylic on canvas
48 x 24 inches
ANA diploma presentation, 1993

Philip Pavia (1912–2005)
NA 2002
Freefall Black and White, 1994
Marble
12 3/4 x 13 x 13 7/8 inches
NA diploma presentation, 2002

Deborah Remington (b. 1935)
NA 1999
Velsuna II, 1973
Color lithograph on white Copperplate
 Deluxe paper
EDITION: 9/12
IMAGE SIZE: 27 15/16 x 21 1/4 inches
SHEET SIZE: 27 15/16 x 21 1/4 inches
NA diploma presentation, 1999

Milton Resnick (1917–2004)
ANA 1980; NA 1989
Straws 14, 1982
Oil on board
40 x 29 7/8 inches
ANA diploma presentation, 1987

Dorothea Rockburne (b. 1932)
NA 2002
Locus Series, 1972
Six etchings and aquatints with oil paint and
 graphite on white Strathmore rag paper
EDITION: 7/42
IMAGE SIZE: 40 x 30 inches each
SHEET SIZE: 40 x 30 inches each
NA diploma presentation, 2004

Marion Roller (b. 1924)
ANA 1994; NA 1994
Empathy, ca. 1995
Terra cotta
10 x 10 x 8 inches
NA diploma presentation, 1995

Tony Rosenthal (b. 1914)
ANA 1992; NA 1994
Alamo, 1967
Hand cut and welded brass and bronze
9 1/2 x 8 x 8 inches
ANA diploma presentation, gift of Tony
 Rosenthal, 1996

Paul Russotto (b. 1944)
ANA Elect 1993; NA 1994

The Broken Mirror, 1982
Oil on canvas
20 x 16 inches
Gift of Paul Resika, 1998

Reuben Tam (1916–1991)
ANA 1975; NA 1987
Monhegan Night, 1956
Oil on canvas
34 x 46 inches
Gift of the artist's estate, 1991

Esteban Vicente (1903–2001)
ANA 1980; NA 1985
Untitled, 1985
Oil on canvas
42 x 50 inches
NA diploma presentation, 1986

Isaac Witkin (1936–2006)
ANA 1994; NA 1994
Study for Eolith, 1993
Bronze, ed. 1/3
32 x 25 x 8 inches
NA diploma presentation, 1996

Joseph Zirker (b. 1924)
ANA 1992; NA 1994
Untitled, 1991
Monotype on white Arches 88 paper
IMAGE SIZE: 53 5/8 x 35 3/8 inches
SHEET SIZE: 60 x 41 3/4 inches
ANA diploma presentation, 1992

Selected Bibliography

Acton, David. *The Stamp of Impulse: Abstract Expressionist Prints.* Exh. cat. New York: Hudson Hills Press; Worcester, MA: In association with the Worcester Art Museum, 2001.

Albee, Edward and Sam Hunter. *Tony Rosenthal.* New York: Rizzoli, 1999.

Albright, Thomas. *Art in the San Francisco Bay Area, 1945–1980: An Illustrated History.* Berkeley: University of California Press, 1985.

Ashton, Dore and Paul Schimmel. *Deborah Remington: A 20-Year Survey.* Exh. cat. Newport Beach, CA: Newport Harbor Art Museum, 1983.

Baur, John I. H. *Nature in Abstraction: The Relation of Abstract Painting and Sculpture to Nature in Twentieth-Century American Art.* New York: The MacMillan Company, 1958.

Barrette, Bill. *Machines of the Mind: Sculpture by Lawrence Fane.* Exh. cat. Richmond, VA: University of Richmond Museums, 2002.

Buchsteiner, Thomas and Ingrid Mössinger, eds. *AnuszkiewiczOpArt.* Tübingen: Institut für Kulturaustasch, 1997.

Bush, Martin H. and Kenworth Moffett. *Goodnough.* Wichita, KS: Wichita University Art Museum, Wichita State University, 1973.

Cathcart, Linda. *Milton Resnick: Paintings, 1945–1985.* Houston, TX: Contemporary Arts Museum, 1985.

Dearinger, David B. and Isabelle Dervaux. *Challenging Tradition: Women of the Academy, 1826–2003.* Exh. cat. New York: National Academy of Design, 2003.

Diehl, Hildebrand, et al., *Robert Mangold.* Wiesbaden, Germany: Museum Wiesbaden, 1998.

Donald Judd: Complete Writings, 1959–1975. Halifax: Nova Scotia College of Art and Design; New York: New York University Press, 1975.

Doty, Robert M. *Will Barnet.* New York: Harry N. Abrams, Inc., 1984.

Duranti, Massimo and Bruno Mantura. *William Crovello: Tokyo/Tuscany.* Exh. cat. Florence: Sala d'Arme di Palazzo Vecchio, 2002.

Ebony, David. *Emily Mason: The Fifth Element.* New York: George Braziller, 2006.

Endberg, Siri and Joan Banach. *Robert Motherwell: The Complete Prints, 1940–1991: Catalogue Raisonné.* Minneapolis: Walker Art Center, 2003.

Fer, Briony. *On Abstract Art.* New Haven and London: Yale University Press, 1997.

Kepes, Gyorgy, ed. *Structure in Art and in Science.* New York: George Braziller, 1965.

Kushner, Marilyn S. *The Prints of Richard Haas, A Catalogue Raisonné: 1974–2004.* New York: John Szoke Editions, 2005.

Landauer, Susan. *Elmer Bischoff: The Ethics of Paint.* Exh. cat. Berkeley: University of California Press; Oakland: Oakland Museum, 2001.

—————. *The San Francisco School of Abstract Expressionism.* Exh. cat. Berkeley: University of California Press; Laguna Beach: Laguna Art Museum, 1996.

Lunde, Karl. *Anuszkiewicz.* New York: Harry N. Abrams, 1977.

Poster, Lauren, ed. *Jules Olitski.* Exh. cat. Marlboro, VT: Four Forty, 2005.

Rose, Barbara. *Frankenthaler.* New York: Harry N. Abrams Inc., Publishers, 1971.

Rosenberg, Harold. "The American Action Painters." *Art News* 51 (December 1952): 22–23, 48–49.

Rothfuss, Joan. *Past Things and Present: Jasper Johns since 1983.* Exh. cat. Minneapolis: Walker Art Center, 2003.

Sandler, Irving. *Antonakos*. New York: Hudson Hills Press, 1999.

Sandler, Irving and Jon Ippolito. *Angelo Ippolito: A Retrospective Exhibition*. Exh. cat. Binghamton, NY: State University of New York at Binghamton, 2004.

Schiff, Richard, et al. *Robert Mangold*. London and New York: Phaidon Press, Inc., 2000.

The Sculpture of Richard Hunt. Exh. cat. New York: Museum of Modern Art; Art Institute of Chicago, 1971.

Siegel, Katy, et al. *High Times, Hard Times: New York Painting, 1967–1975*. Exh. cat. New York: Independent Curators International, 2006.

Spring, Justin. *Wolf Kahn*. New York: Harry N. Abrams, Inc., 1996.

Stavitsky, Gail, et al. *Will Barnet: A Timeless World*. Exh. cat. Montclair, NJ: Montclair Art Museum, 2000.

Terenzio, Stephanie. *The Painter and the Printer: Robert Motherwell's Graphics, 1943–1980*. Exh. cat. New York: American Federation of Arts, 1980.

Tucker, Marcia. *Early Work by Five Contemporary Artists: Ron Gorchov, Elizabeth Murray, Dennis Oppenheim, Dorothea Rockburne, Joel Shapiro*. Exh. cat. New York: New Museum of Contemporary Art, 1977.

Varnedoe, Kirk, ed. *Jasper Johns: Writings, Sketchbook Notes, Interviews*. New York: Museum of Modern Art, 1996.

——————. *Pictures of Nothing: Abstract Art Since Pollock*. Princeton and Oxford: Princeton University Press, 2006.

Warren, Lynne, ed. *Art in Chicago, 1945–1995*. Exh. cat. New York: Thames and Hudson; Chicago: Museum of Contemporary Art, 1996.

Wei, Lilly. *After the Fall: Aspects of Abstract Painting Since 1970*. Exh. cat. Staten Island: Snug Harbor Cultural Center, 1997.

Wilkin, Karen. *Isaac Witkin*. New York: Hudson Hills Press, 1998.

Young, Warren R. "Op Art." *Life* 57 (December 28, 1964): 132–140.

Index